*

A WAY OF SEEING

*

ENLARGED EDITION
WITH TWENTY-FOUR ADDITIONAL
PHOTOGRAPHS

*

HELEN LEVITT

A Way of Seeing

WITH
AN ESSAY
BY
JAMES AGEE

*

HORIZON PRESS
NEW YORK

TO JANICE

FIRST PRINTING OF
ENLARGED EDITION WITH A CORRECTED
TEXT AND 24 ADDITIONAL PHOTOGRAPHS
HALFTONE PHOTOGRAPHY BY RICHARD BENSON
PRINTING BY MERIDEN GRAVURE COMPANY
BINDING BY PUBLISHERS BOOK BINDERY
TYPESETTING BY G & S TYPESETTERS
DESIGN BY MARVIN HOSHINO

TR
653
L45
1981

HORIZON PRESS
156 FIFTH AVENUE · NEW YORK 10010

Helen Levitt was born and educated in New York City. She made these photographs in New York in the 1940s. None of the photographs is intended as a social or psychological document. Several are records of street and sidewalk drawings; most of the others can best be described as lyrical photographs. In this book they are arranged, numbered but without captions, in an order suggested by the essay.

THE MIND and the spirit are constantly formed by, and as constantly form, the senses; and misuse or neglect the senses only at grave peril to every possibility of wisdom and well-being. The busiest and most abundant of the senses is that of sight. The sense of sight has been served and illuminated by the visual arts for as long, almost, as we have been human. For a little over a hundred years, it has also been served by the camera. Well used, the camera is unique in its power to develop and to delight our ability to see. Ill or indifferently used, it is unique in its power to defile and to destroy that ability. It is clear enough by now to most people, that "the camera never lies" is a foolish saying. Yet it is doubtful whether most people realize how extraordinarily slippery a liar the camera is. The camera is just a machine, which records with impressive and as a rule very cruel faithfulness, precisely what is in the eye, mind, spirit, and skill of its operator to make it record. Since relatively few of its operators are notably well endowed in any of these respects, save perhaps in technical skill, the results are, generally, disheartening. It is probably well on the conservative side to estimate that during the past ten to fifteen years the camera has destroyed a thousand pairs of eyes, corrupted ten thousand, and seriously deceived a hundred thousand, for every one pair that it has opened, and taught.

It is in fact hard to get the camera to tell the truth; yet it can be made to, in many ways and on many levels. Some of the best photographs we are ever likely to see are innocent domestic snapshots, city postcards, and news and scientific photographs. If we know how, moreover, we can enjoy and learn a great deal from essentially untrue photographs, such as studio portraits, movie romances, or the national and class types apotheosized in ads for life insurance and feminine hygiene. It is a good deal harder to tell the truth, in this medium, as

in all others, at the level of perception and discipline on which an artist works, and the attempt to be "artistic" or, just as bad, to combine "artistry" with something that pays better, has harmed countless photographs for every one it has helped, and is harming more all the time. During the century that the camera has been available, relatively few people have tried to use it at all consistently as an artist might, and of these very few indeed could by any stretch of courtesy be called good artists. Among these few, Helen Levitt is one of a handful who have to be described as good artists, not loosely, or arrogantly, or promotively, but simply because no other description will do.

In every other art which draws directly on the actual world, the actual is transformed by the artist's creative intelligence, into a new and different kind of reality: aesthetic reality. In the kind of photography we are talking about here, the actual is not at all transformed; it is reflected and recorded, within the limits of the camera, with all possible accuracy. The artist's task is not to alter the world as the eye sees it into a world of aesthetic reality, but to perceive the aesthetic reality within the actual world, and to make an undisturbed and faithful record of the instant in which this movement of creativeness achieves its most expressive crystallization. Through his eye and through his instrument the artist has, thus, a leverage upon the materials of existence which is unique, opening to him a universe which has never before been so directly or so purely available to artists, and requiring of his creative intelligence and of his skill, perceptions and disciplines no less deep than those required in any other act of aesthetic creation, though very differently deprived, and enriched.

The kind of beauty he records may be so monumentally static, as it is in much of the work of Mathew Brady, Eugène Atget, and Walker Evans, that the undeveloped eye is too casual and wandering to recognize it. Or it may be so filled with movement, so fluid and so transient, as it is in much of the work of Henri Cartier-Bresson and of Miss Levitt, that the undeveloped eye is too slow and too generalized to foresee and to isolate the most illuminating moment. It would be mistaken to suppose that any of the best photography is come at by intellection; it is, like all art, essentially the result of an intuitive process, drawing on all that the artist *is* rather than on anything he thinks, far less theorizes about. But it seems quite natural, though none of the artists can have made any choice in the matter, that the static work is generally the richest in meditativeness, in mentality, in atten-

tiveness to the wonder of materials and of objects, and in complex multiplicity of attitudes of perception, whereas the volatile work is richest in emotion; and that, though both kinds, at their best, are poetic in a very high degree, the static work has a kind of Homeric or Tolstoyan nobility, as in Brady's photographs, or a kind of Joycean denseness, insight and complexity resolved in its bitter purity, as in the work of Evans; whereas the best of the volatile work is nearly always lyrical.

It is remarkable, I think, that so little of this lyrical work has been done; it is perhaps no less remarkable that, like nearly all good photographic art, the little that has been done has been so narrowly distributed and so little appreciated. For it is, after all, the simplest and most direct way of seeing the everyday world, the most nearly related to the elastic, casual and subjective way in which we ordinarily look around us. One would accordingly suppose that, better than any other kind of photography, it could bring pleasure, could illuminate and enhance our ability to see what is before us and to enjoy what we see, and could relate all that we see to the purification and healing of our emotions and of our spirit, which in our time are beguiled with such unprecedented dangerousness towards sickness and atrophy.

I do not at all well understand the reasons for the failure, but a few possibilites may be worth mentioning in passing. For a long time the camera was too slow, large, and conspicuous to work in the fleeting and half-secret world which is most abundant in lyrical qualities. More recently it has become all but impossible, even for those who had it in the first place, to maintain intact and uncomplicated the simple liveliness of soul and of talent without which true lyrical work cannot be done. As small, quick, foolproof cameras became generally available, moreover, the camera has been used so much and so flabbily by so many people that it has acted as a sort of contraceptive on the ability to see. And more recently, as the appetite for looking at photographs has grown, and has linked itself with the worship of "facts," and as a prodigious apparatus has been developed for feeding this appetite, the camera has been used professionally, a hundred times to one, in ways which could only condition and freeze the visual standards of a great majority of people at a relatively low grade.

As a further effect of this freezing and standardization, photographers who really have eyes, and who dare to call their eyes their own, and who do not care to modify them towards this standardized, acceptable style, have found it virtually impossible to

get their work before most of those who might enjoy it; or to earn, through such work, the food, clothing, shelter, leisure, and equipment which would make the continuance of that work possible. Almost no photographer whose work is preeminently worth looking at has managed to produce more than a small fraction of the work he was capable of, and the work, as a rule, has remained virtually unknown except to a few friends and fellow artists. This is true to a great extent, of course, of artists who work in any field. Yet distinctions, standards, and assumptions exist and have existed for centuries which guarantee a good poet or painter or composer an audience, if generally a small one; and these are not yet formed in relation to photographs. In its broad design, however, this is a familiar predicament, as old as art itself, and as tiresome at least, one may assume, to the artists who suffer the consequences as to the non-artists to whom it is just a weary cliché. I don't propose to discuss who, if anyone, is to blame, being all the less interested in such discussion because I don't think anyone is to blame. I mention it at all only because I presume that the distinction between faithfulness to one's own perceptions and a readiness to modify them for the sake of popularity and self-support is still to be taken seriously among civilized human beings; and because it helps, in its way, to place and evaluate Miss Levitt's work.

AT LEAST a dozen of Helen Levitt's photographs seem to me as beautiful, perceptive, satisfying, and enduring as any lyrical work that I know. In their general quality and coherence, moreover, the photographs as a whole body, as a book, seem to me to combine into a unified view of the world, an uninsistent but irrefutable manifesto of a way of seeing, and in a gentle and wholly unpretentious way, a major poetic work. Most of these photographs are about as near the pure spontaneity of true folk art as the artist, aware of himself as such, can come; and an absolute minimum of intellection, of technical finesse, or of any kind of direction or interference on the part of the artist as artist stands between the substance and the emotion and their communication.

It is of absolute importance, of course, that all of these photographs are "real" records; that the photographer did not in any way prepare, meddle with, or try to improve on any one of them. But this is not so important of itself as, in so many of them, unretouched reality is shown transcending itself. Some, to be sure, are so perfectly simple, warm and direct in their understanding of a face or of an emotion that they are

likely to mean a great deal to anyone who cares much for human beings: it would be hard to imagine anyone who would not be touched by all that is shown – by all that so beautifully took place in the unimagined world – in such a photograph as 33. Readers who particularly like children will find here as much to meditate, and understand, or be mystified by, as anyone, so far as I know, has ever managed to make permanent about children. Sociologically and psychologically, the photographs seem to be only the more rich and illuminating because they are never searching out or exploiting, in their subjects, such purposes – far less the still narrower and more questionable purposes of the journalist, humanitarian, or "documentor." There is in fact a great deal that can be seen here by the purely rational mind and eye, or by a person who is, in a purely rational way, interested in people, in relationships, and in cities.

I would not for a moment want to try to persuade any reader who mistrusts the irrational, to suspend his mistrust, and look further into these pictures. I am nevertheless convinced that the photographs cannot be fully enjoyed, or adequately discussed, on a purely naturalistic or rational basis. Many of them prove, rather, that the actual world constantly brings to the surface its own signals, and mysteries. At its simplest this kind of signaling could be called purely aesthetic; the postures of the girl and boy in 43 and their spacing on the pavement is one of many examples. But even here I think there is more than can be covered by the word aesthetic, even after you have added the great simplicity, power, and complexity of its full human and rational content. I think there is also in this spacing, and in the strange posture of the boy as it relates to bare space and to the young girl, a quality of mystery – a strong undertone even, against the picture's brave and practical melancholy, of terror. Again, I would not insist on this, to the reader who does not recognize it or who is not interested. Now the forces of beauty and fear in this picture might be suspect, if they drew one to enjoy them for their own sake alone, and it is possible, I realize, to enjoy this and many other of the pictures in this precious and limited, inhuman way. But it seems to me that the super-rational beauty, fear, and mystery, and the plain strength and sadness of the girl, and her particular moment and stance in her own and in universal existence, all powerfully interdepend upon and enhance one another, reverberating like mirrors locked face to face the illimitable energies set up in the paradox formed in the irrefutably actual as perceived by the poetic

imagination. I suspect that only the reader who recognizes this, in his own terms, will thoroughly understand and agree with what I mean by a photograph as a good work of art; or by a lyrical photograph.

The reader who does, is in a position fully to enjoy these photographs. He will realize how constantly the unimagined world is in its own terms an artist, and how deep and deft the creative intelligence must be, to recognize, foresee, and make permanent its best moments. Even in the most benignly open, simple-looking kind of portrait he will see this, and it will add its beauty and vitality: the toes of the baby in 66 and the glasses of the man, and the knobbed, shining wood of the chair, and the man's knobbed, polished shoes, and the round foreheads and round heads and faces of the man and the baby, all assemble their delicate order like so many syllables in a line of poetry, to enhance the already great charm of the surface content. The rifted asphalt and the burnt match in 3 would lose much of their power if a painter had invented them or the photographer had arranged them; as it is they combine with the drawing to testify to the silent cruelty of nature.

Many people, even some good photographers, talk of the "luck" of photography, as if that were a disparagement. And it is true that luck is constantly at work. It is one of the cardinal creative forces in the universe, one which a photographer has unique equipment for collaborating with. And a photographer often shoots around a subject, especially one that is highly mobile and in continuous and swift development— which seems to me as much his natural business as it is for a poet who is really in the grip of his poem to alter and re-alter the words in his line. It is true that most artists, though they know their own talent and its gifts as luck, work as well as they can against luck, and that in most good works of art, as in little else in creation, luck is either locked out or locked in and semi-domesticated, or put to wholly constructive work; but it is peculiarly a part of the good photographer's adventure to know where luck is most likely to lie in the stream, to hook it, and to bring it in without unfair play and without too much subduing it. Most good photographs, especially the quick and lyrical kind, are battles between the artist and luck, and the happiest victories for the artist are draws. Luck can of course spoil as many photographs as it contributes to, or makes, and can seldom do anything for the photographer who lacks an eye for it, unless he is wholly absorbed in some quite different intention, or is thoroughly naive. It is luck, if you like,

that turned the warlike frieze in 21 into a wonderful dance, and gave it its strange frame of electrical wiring; but is it? Is it not more likely, when you look with care at the respective postures and ages of the people in 14, or at the relationship between the woman and the bicycle in 60, that surreptitiously, unknown even to the performers, though in broad daylight, human beings and their streets continually evolve some of their most unutterable meanings, as a dance?

LIKE MOST good artists, Miss Levitt is no intellectual and no theorist; she works, quite simply, where she feels most thoroughly at home, and that, naturally enough, is where the kind of thing that moves and interests her is likely to occur most naturally and in best abundance. So there was nothing preconceived about the boundaries she has set around her subject matter. Yet it is worth noticing that in much of her feeling for streets, strange details, and spaces, her vocabulary is often suggestive of and sometimes identical with that of the Surrealists. In other words, there seems to be much about modern cities which of itself arouses in artists a sensitiveness, in particular, to the tensions and desolations of creatures in naked space. But I think that in Miss Levitt's photographs the general feel-

ing is rather that the surrealism is that of the ordinary metropolitan soil which breeds these remarkable juxtapositions and moments, and that what we call "fantasy" is, instead, reality in its unmasked vigor and grace. It is also worth noticing that nearly all the people in her photographs are poor; that most of them are of the relatively volatile strains; that many are children. It is further worth realizing that there is a logic and good sense about this, so far as her work is concerned. In children and adults alike, of this pastoral stock, there is more spontaneity, more grace, than among human beings of any other kind; and of all city streets, theirs are most populous in warm weather, and most abundant in variety and in beauty, in strangeness, and in humor.

A great lyrical artist might still possibly find much, among people and buildings of the middle and rich classes, to turn to pure lyrical account. But it seems hardly necessary to point out that flowers grow much more rarely in that soil, perhaps especially in this country at this time, than weeds and cactuses; and that there is much more in that territory to interest the artist who is fascinated by irony, diagnosis, and the terrifying complexities of self-deceit and of evil, than there is for the lyrical artist. I cannot believe it is meaningless that with a

few complicated exceptions, our only first-rate contemporary lyrics have gotten their life at the bottom of the human sea: aside from Miss Levitt's work I can think of little outside the best of jazz. Moreover, specialized as her world is, it seems to me that Miss Levitt has worked in it in such a way that it stands for much more than itself; that it is, in fact, a whole and round image of existence. These are pastoral people, persisting like wild vines upon the intricacies of a great city, a phantasmagoria of all that is most contemporary in hardness of material and of appetite. In my opinion they embody with great beauty and fullness not only their own personal and historical selves but also, in fundamental terms, a natural history of the soul, which I presume also to be warm-blooded, and pastoral, and, as a rule, from its first conscious instant onward, as fantastically misplanted in the urgent metropolis of the body, as the body in its world.

So far, I have avoided any attempt to discuss the "meanings" of the photographs, feeling that this is best left as an affair between the pictures themselves and the reader. By less direct means I have tried to furnish the chance reader who may feel that he lacks it, enough suggestions about such pictures as these, that he may go on to their full enjoyment without further interruption by words. But because I realize that we are all so deeply caught in the tyranny of words, even where words are not needed, that they have sometimes to be used as keys to unlock their own handcuffs, I have tried, from here on, to give a more directly suggestive paraphrase. That this paraphrase is extravagant, and that the "story" the pictures tell is arguable, from a rational point of view, and in some ways very sentimental from any point of view, I realize, with regret. The attempt is not rational because so much that is important in the pictures is not rational and because this is liable, I fear, to be insufficiently recognized. I am counting on the absolute reality of the pictures, and on the reader's rational use of eye and mind, to dress the boat; and I make this attempt chiefly because I feel that much of the enjoyment of the pictures depends on an appreciation of the tension which they create, and reveal, between the unimagined world, and the imaginable.

The overall preoccupation in the photographs is, it seems to me, with innocence—not as the word has come to be misunderstood and debased, but in its full, original wildness, fierceness, and instinct for grace and form; much may be suggested to some readers by Yeats's phrase, "the ceremony of innocence." This is the record of an

ancient, primitive, transient, and immortal civilization, incomparably superior to our own, as it flourishes, at the proud and eternal crest of its wave, among those satanic incongruities of a twentieth century metropolis which are, for us, definitive expressions and productions of the loss of innocence.

We begin not with the creatures of this civilization, but with their hieroglyphs, their rock drawings, their cave paintings. The intuitions of a child with chalk have so utilized a stamped tin wreath (1) as to create a female head which could also be an image of the sun or the moon; and, as a magnet beneath paper aligns a scatter of iron filings, it commands every disparate element within the frame of the photograph into a grandly unified, cryptic significance. Then, the flow and lightness of its drawing as sure as somnambulism, the floated beatitude of an unborn child (2) in a blandly anachronistic baby's dress; its carefully emphasized smile, untouched by any interposition of consciousness between the hand and the source of fullest knowledge, is no more accident than it is intellection.

The first living creature we see (4) is also prenatal: majestic, of uncertain sex, its weapon sheathed at rest, its features obscured, generalized and portentous as those of the celestial image in 1, it stands monarchic, veiled in its placenta. The children in

picture 5, peering into the open world from within their primal harbor, have no need of the bridal shroud of birth or of its world-faring replica, the mask; but in their relative postures, and attitudes toward their masks, the three children in 7 are a definitive embodiment of the first walk into the world's first morning. The boys of 9, treed and at home in their jungle's stony shade, touch the drumhead of this world's mystery beyond the touch of words; the boy of 10 epitomizes for all human creatures in all times that moment when masks are laid aside.

The cardinal occupations of the members of this culture are few, primordial, and royal, being those of hunting, war, art, theater, and dancing. Dancing, indeed, is implicit in nearly all that they do — as in the heroic frieze of 21, and the centrifugal, fire-dance fury of 24; or the quieted boy beside the sleeping lion (29) or, with the exquisite dignity of the greatest of dancers, in the image of the solitary duellist (30). But subtly, ineluctably, the quality of citizenship in this world where all are kings and queens begins to shift and, almost invariably, to decline and to disintegrate. The rock drawings lose their intuitive and hieratic brilliance if not, at first, their poetic vitality; they are no longer prehistoric or in the artist's sense religious; they have

xiii

become mere bulletins of desire, aggression, and contempt. And in each child, from very early, the germ of the death of childhood is at work. In the child of 36, it is enthroned and quiescent; he is merely so bemused, for the moment by the world before his world, that the face has become fetal. The little boy in the next picture (37) still acts with the angelic directness of his world at its most free; the little girls in the same picture embody a later, sadder stage. The children in 39 are already engulfed as deeply in the future as in the present or the past, and I know of no record of man-eating motherhood more accurate or more fearsome. In 40, this is balanced by an image of the gentle elegance possible, in the age that can still survive it whole, to prepropagative love. Adolescence is a kingdom of fallen and still falling angels, but it is yet a kingdom, with its own kinds of wild animal glamor (42), with profundities of grave purity which are peculiar to it (47); with its unappeasable hunger and pity (50), and its own awful threshold to the world beyond — that Babylonian captivity in which dreams are either manufactured by outside authorities or rest, as a rule, forever unformed and unsatisfied. On this threshold it is still possible to retain something of the ancient genius for gaiety and for symbol (52); but one has also become forcefully aware of what we commonly call reality in its official form, its lowest common denominator.

In that next world, some hold their sexuality in such esteem (53), or use it with such affectionate comfort (54), that it would be mistaken to feel that they have fallen through the floors of two kingdoms into a scullery chaos of gracelessness; they are indications, rather, that human beings do not inevitably, or anyhow invariably, destroy themselves. And some retain the quality of delight (55), if not for themselves then at least for others, and as innocently delicious creatures at large and unconquerable in a less than delicious world. But the more customary destiny is much more dark. A woman, crossing a street (60), can seem to beckon towards blind alleys of unthinkable sorrow and fright. Picture 62 is so perfect a theatrical tableau that it would be questionable among such photographs as these if it were in any way staged or posed, but stands, as it is, as a beautiful example of nature imitating art. In its pathetic, relatively rational verbosity, moreover, it marks a difference wider than that of race with the prodigious image (64) of anguish and consolation.

Those who were royal and who have declined into helotry become royal once more, if only briefly, in the eyes of those whom they bring forth and enslave them-

selves to. There is the warmest and deepest kind of delight, and the only answer to age save those beyond this world, in the portrait of the men with the baby (65). I feel it is endearing beyond talking of, and beyond tears. But I do not know of any image so completely eloquent as that in the last picture (68), of all that is most gracious, great, and resplendent of well-being and of loveliness, that loving servitude can mean, and bring in blessing. No one could write, paint, act, dance, or embody in music, the woman's sheltering and magnanimous arm, or tilt and voice of smiling head, or bearing and whole demeanor; which are also beyond and above any joy or beauty which a child could possibly experience or embody. She is at once the sweetness of life and the tenderness of death; the soul victorious in the body's world; the salvation and immortality of innocence.

As I hope the reader will have found, before reading this last section, the photographs can speak much more eloquently and honestly for themselves. It is hoped that in some degree this introduction may have served not only an immediate but a more general purpose, of helping to open, for some readers, a further ability to see and enjoy, without the further interference of words, still other photographs, good and bad, and the ordinary world. For although it would be foolish to hope that a purification of the sense of sight can liberate and save us, any more than anything else is likely to, it might nevertheless do much in restoring us toward sanity, goodwill, calm, acceptance, and joy. Goethe wrote that it is good to think, better to look and think, best to look without thinking. Such photographs as these can do much to show us what he meant.

James Agee, New York City, 1946

xv

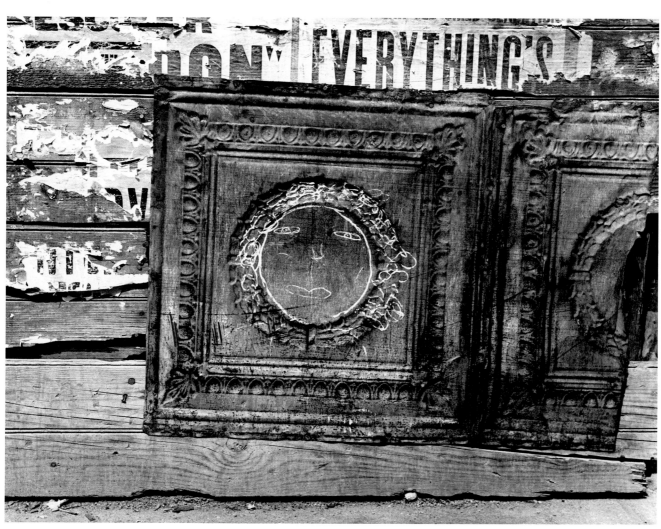

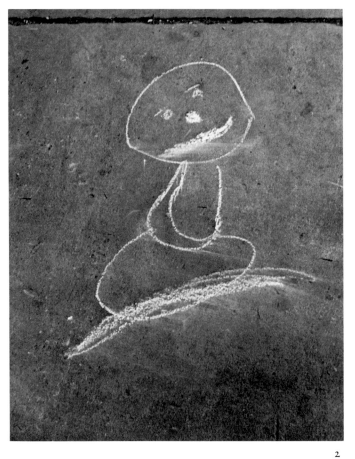

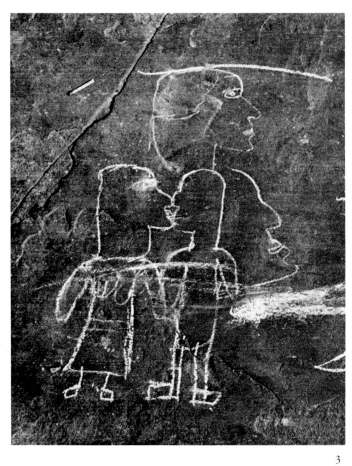

2

3

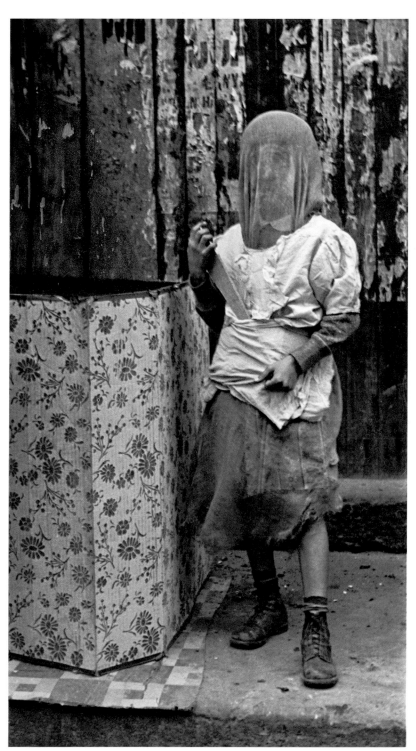

4

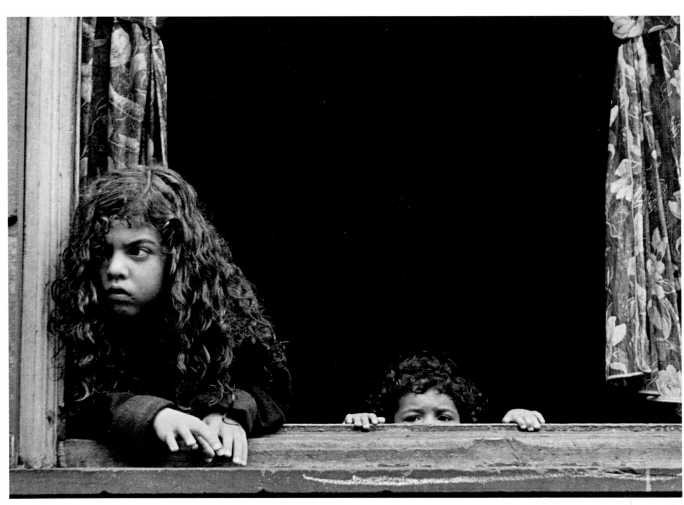

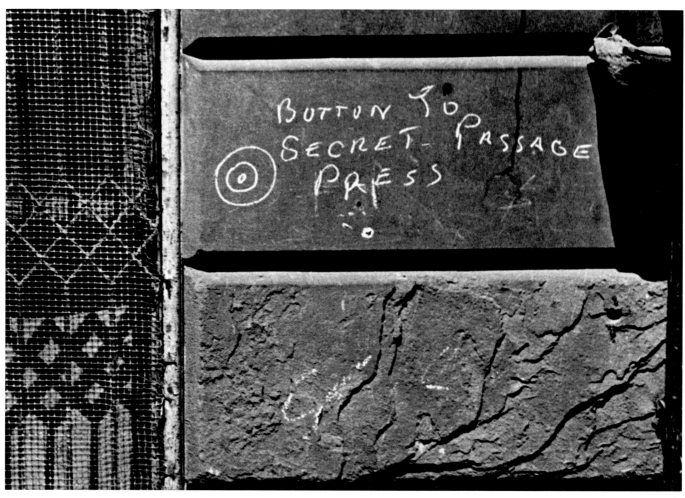

6

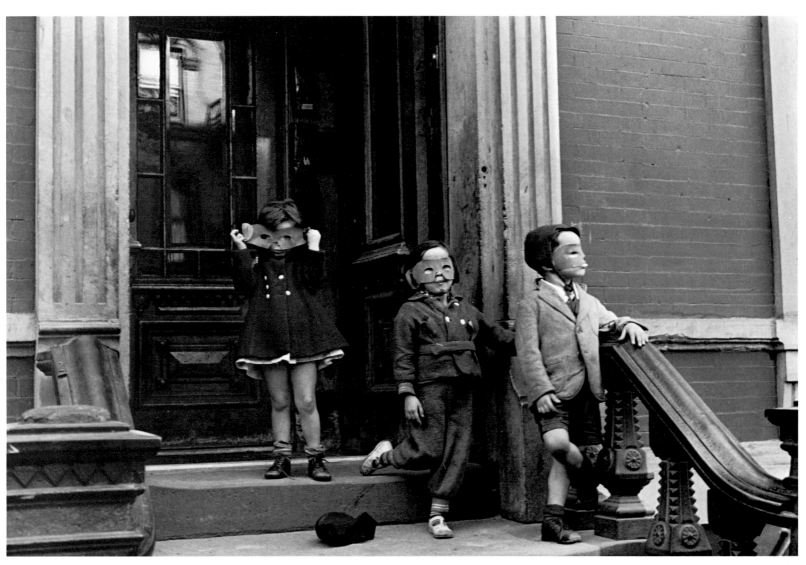

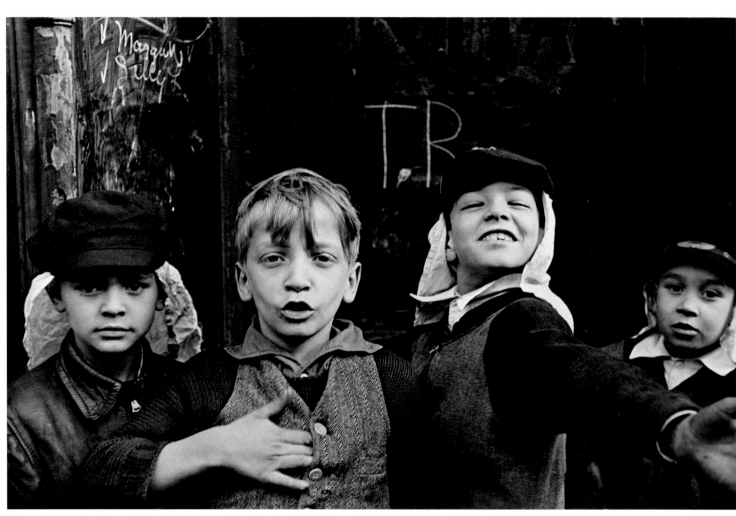

8

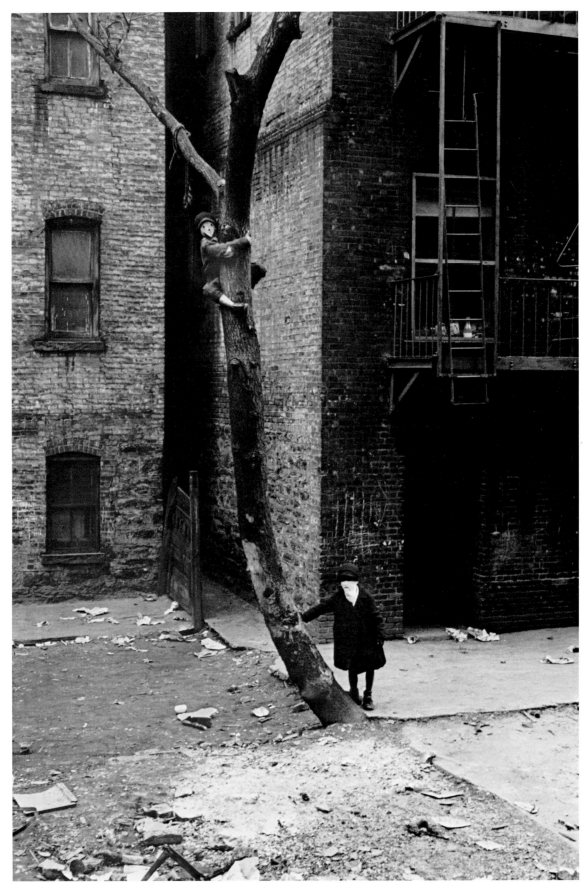

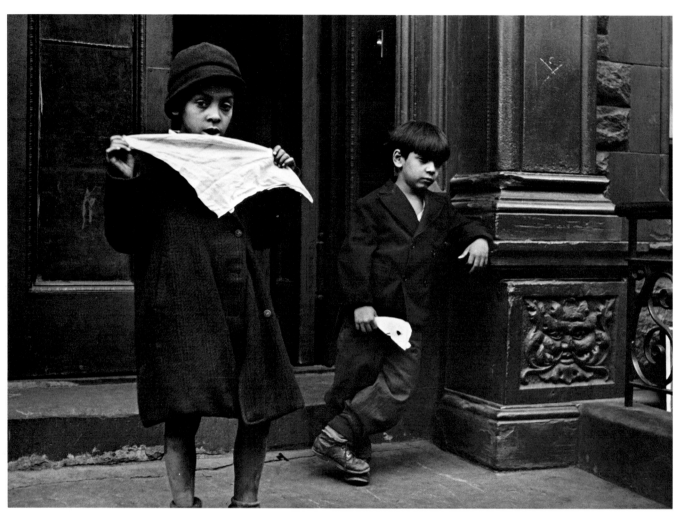

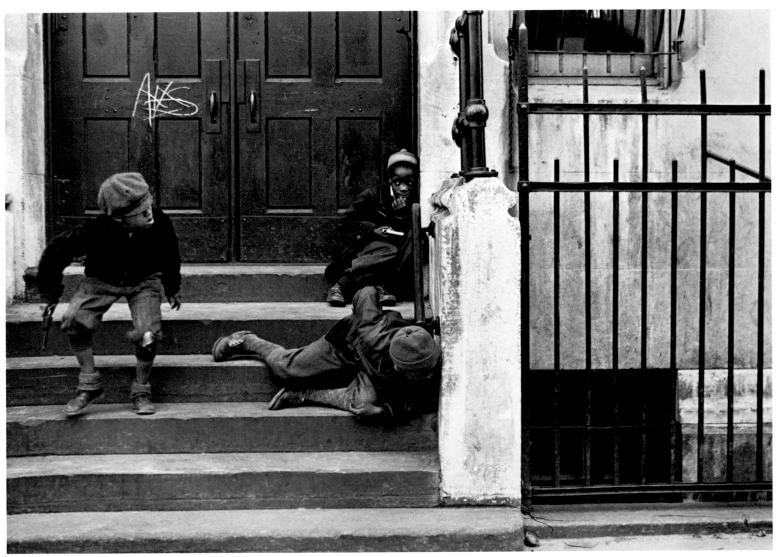

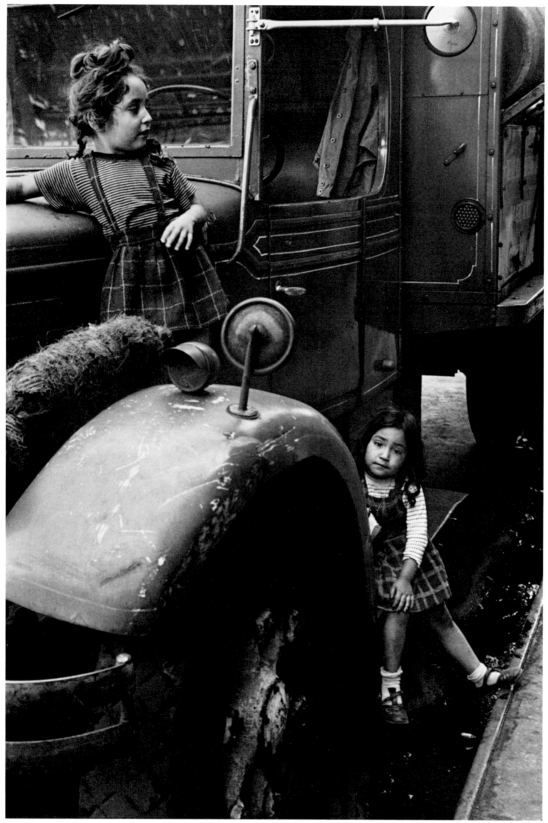

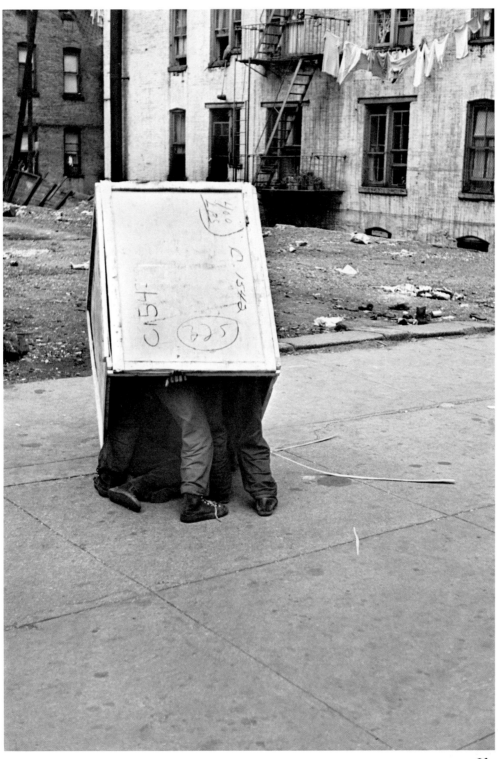

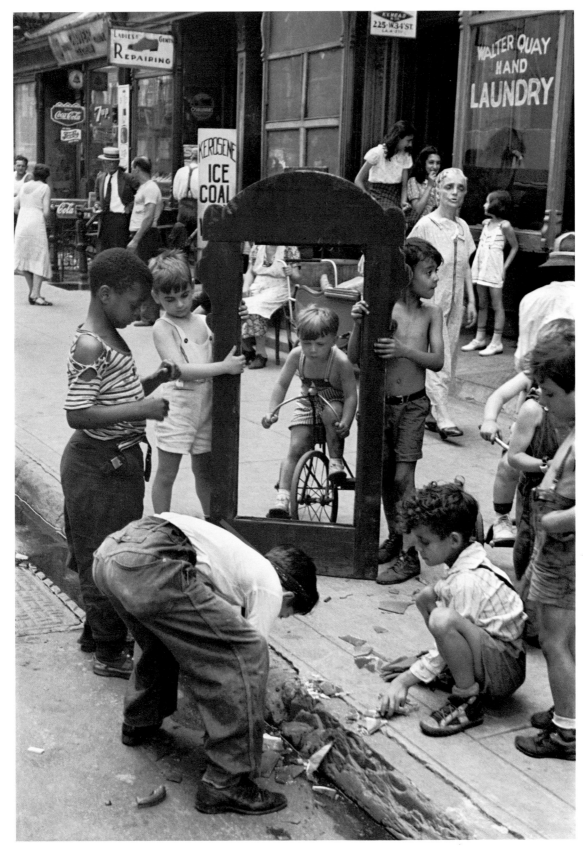

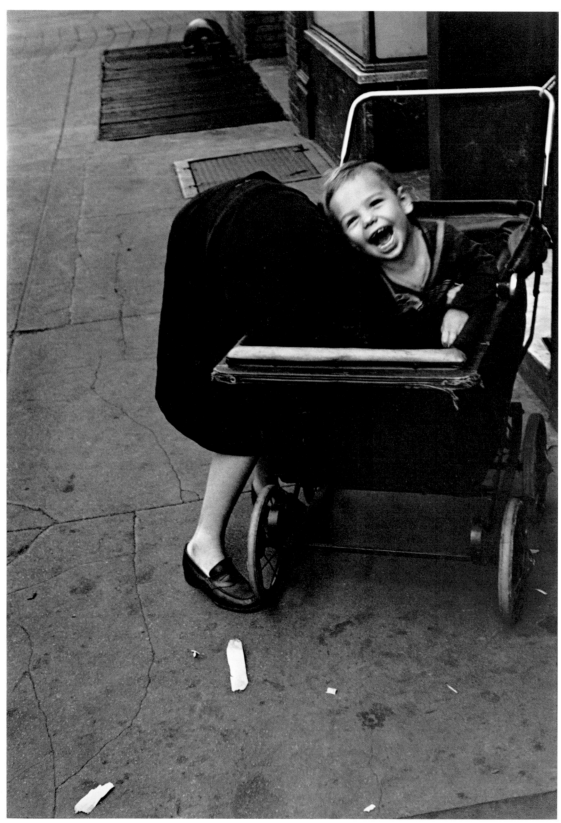

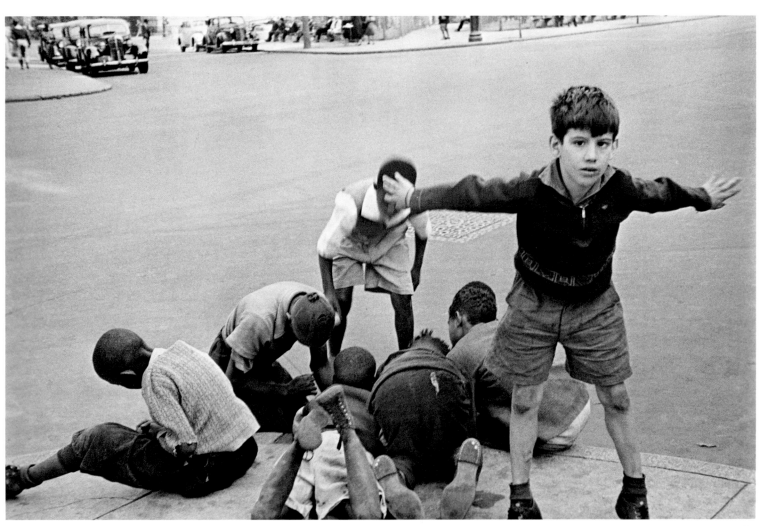

16

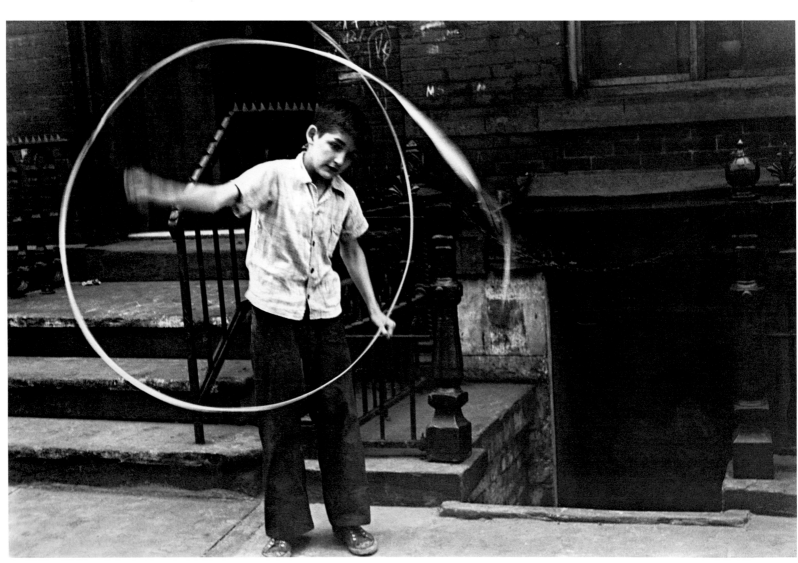

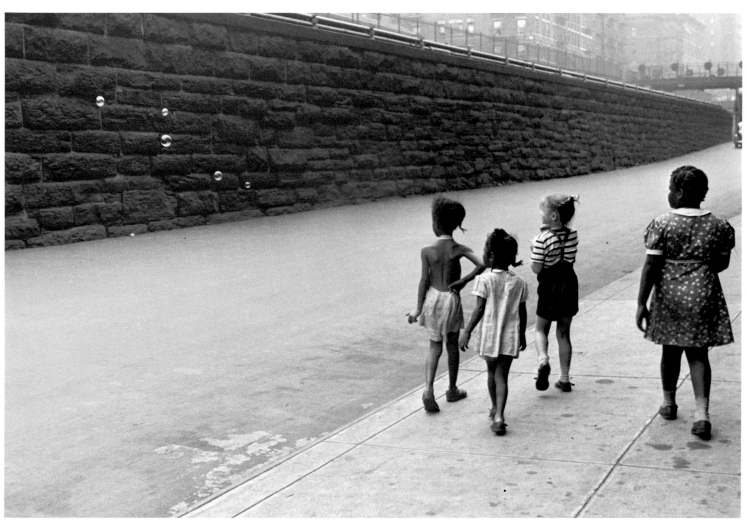

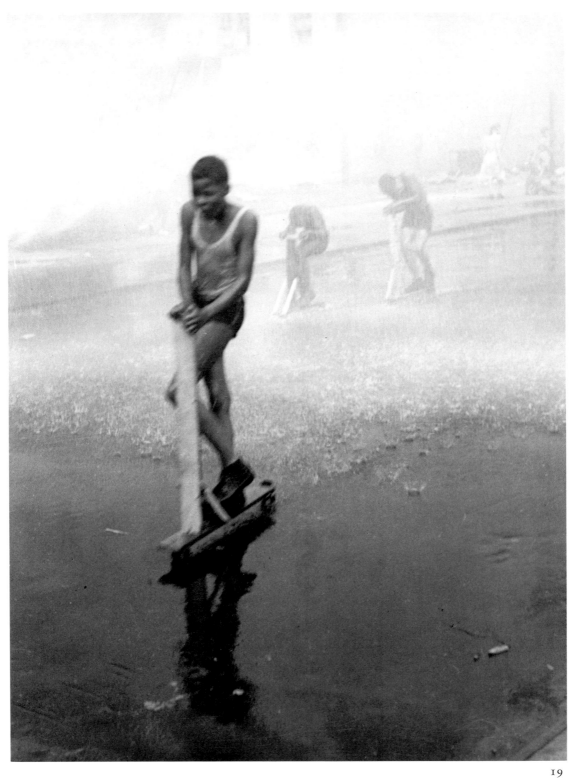

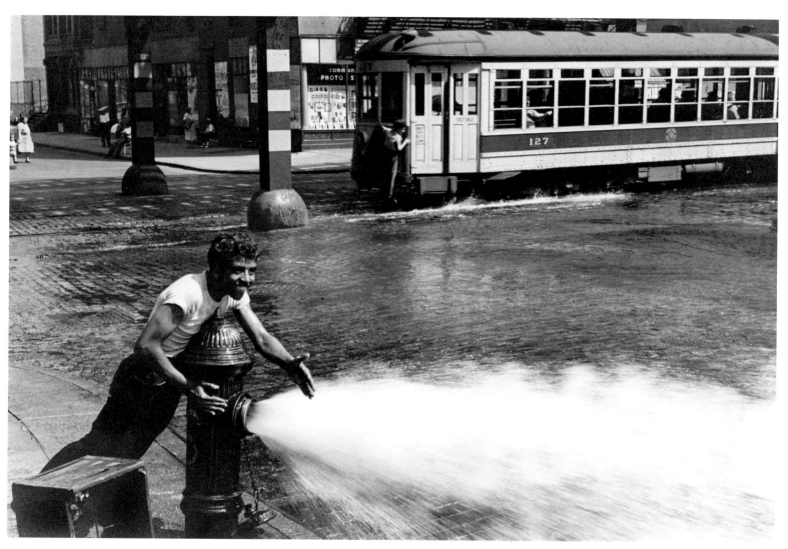

20

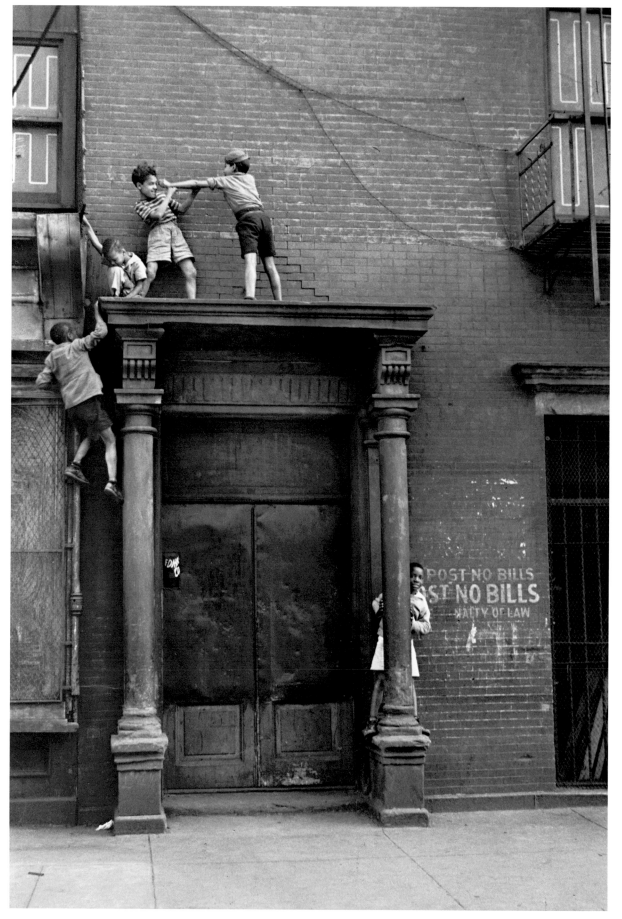

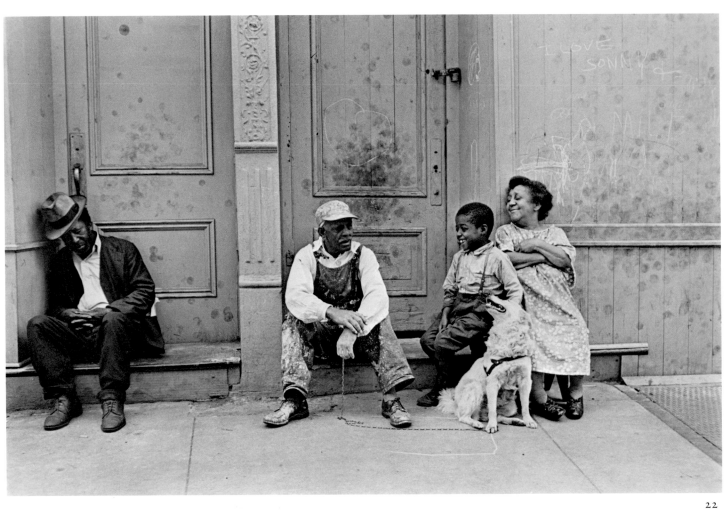

22

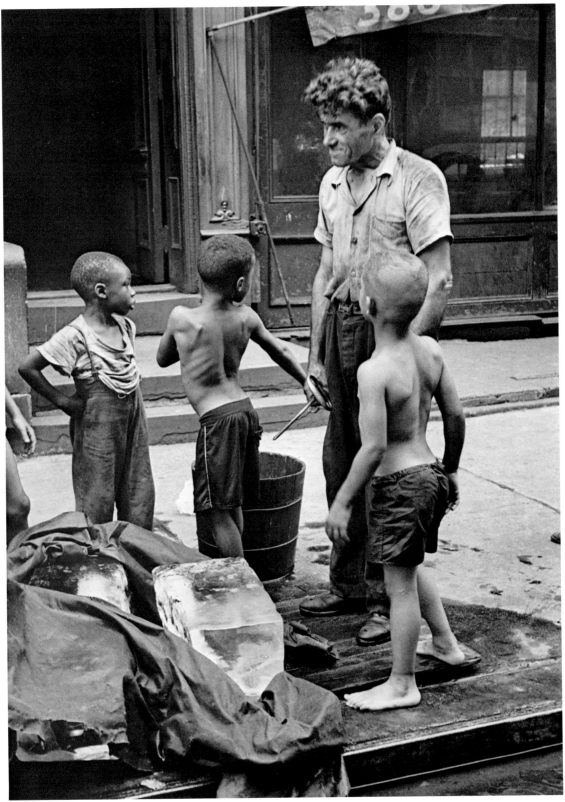

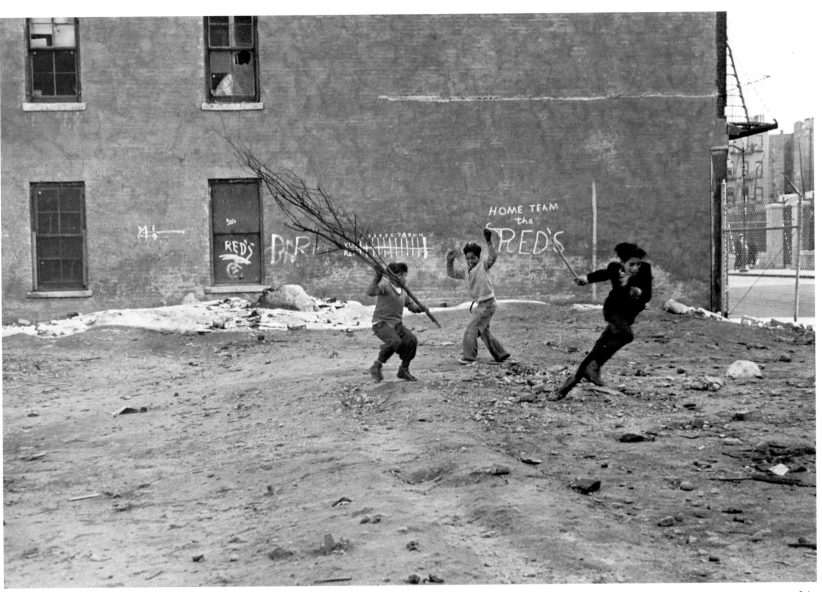

24

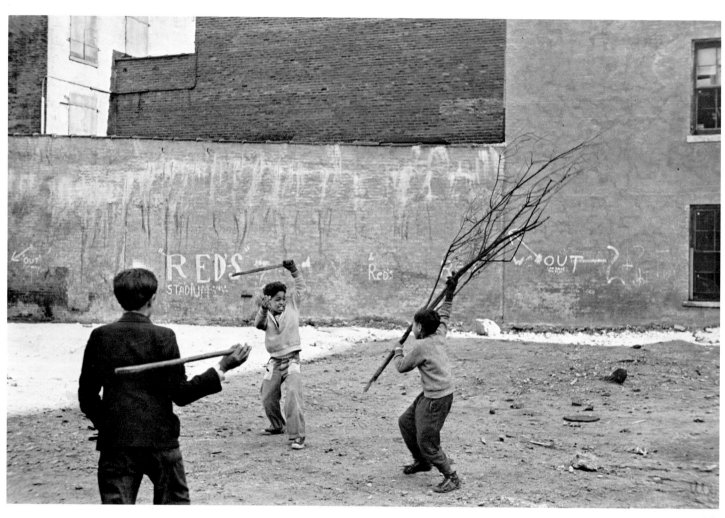

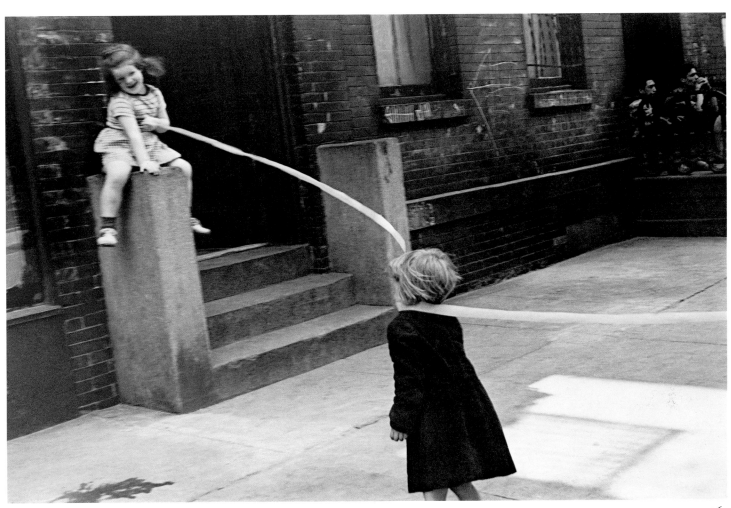

26

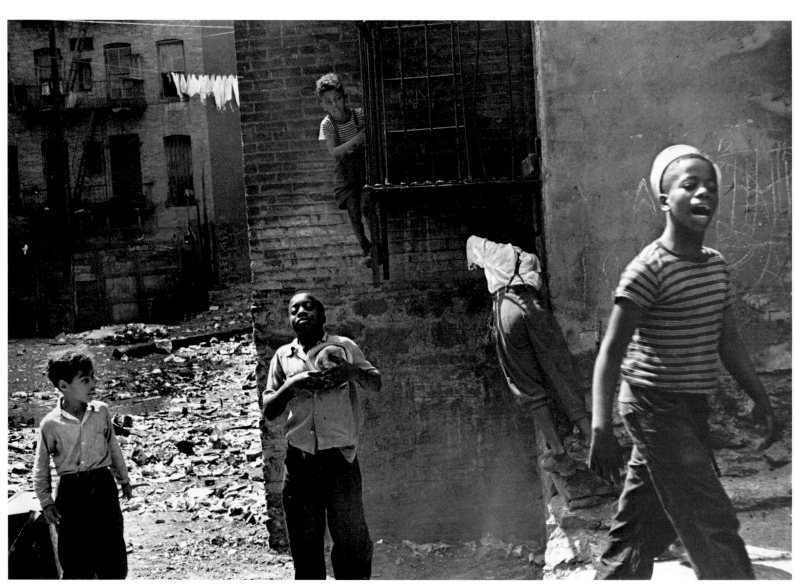

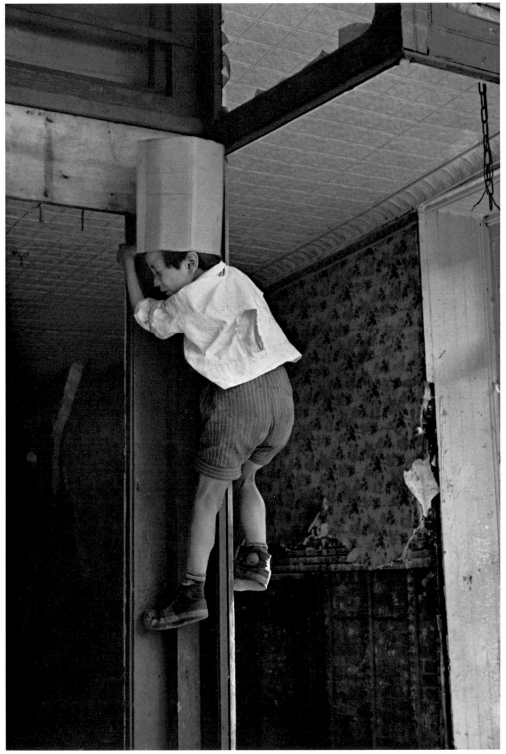

28

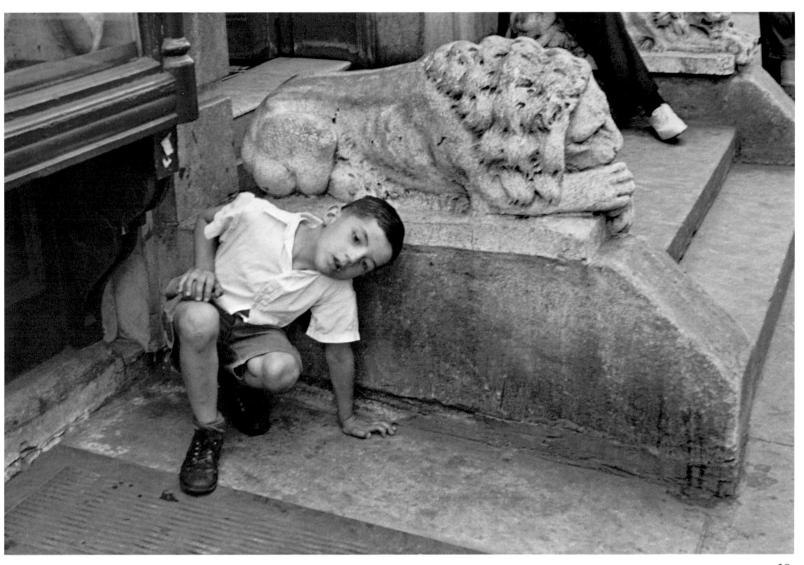

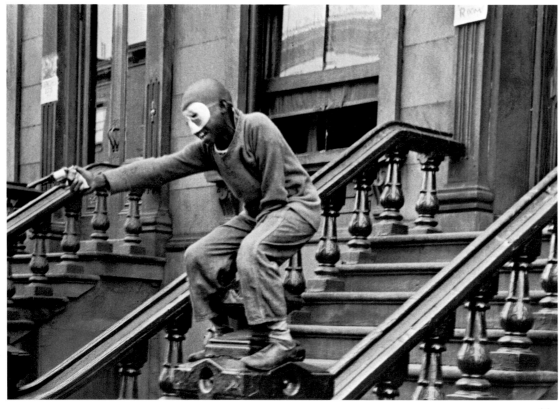

30

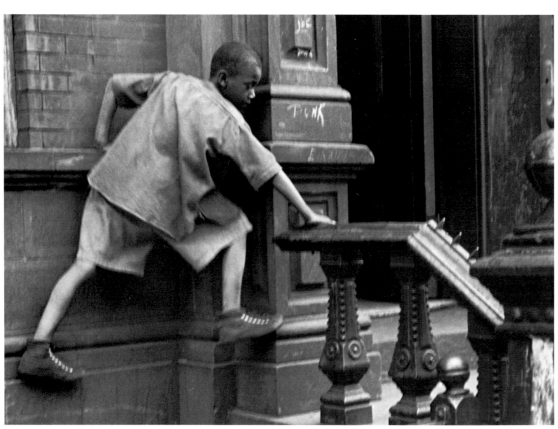

31

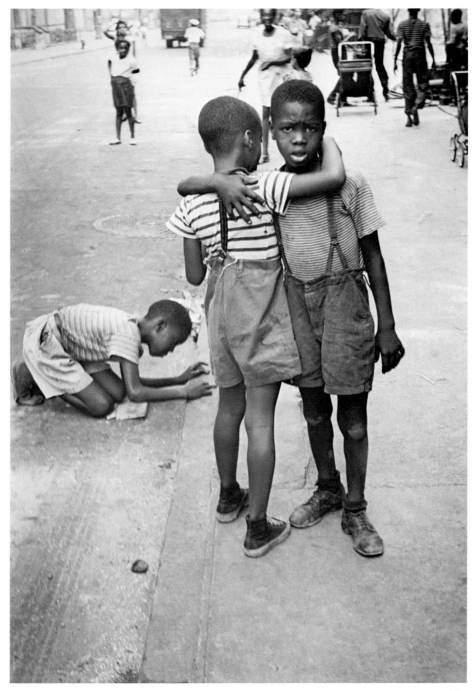

32

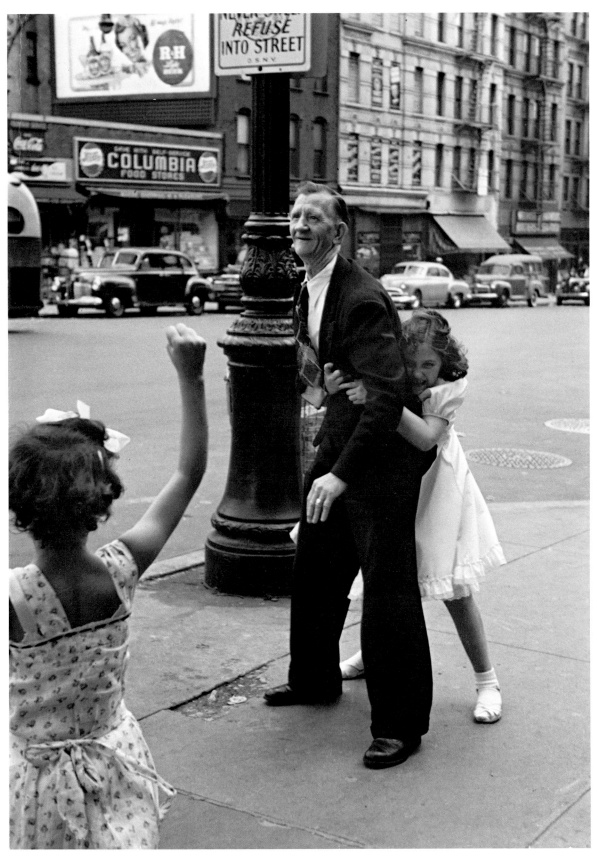

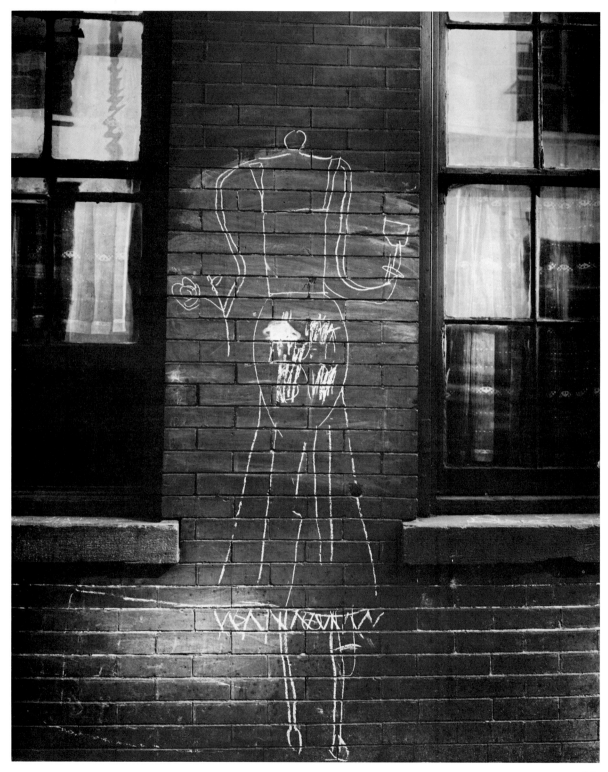

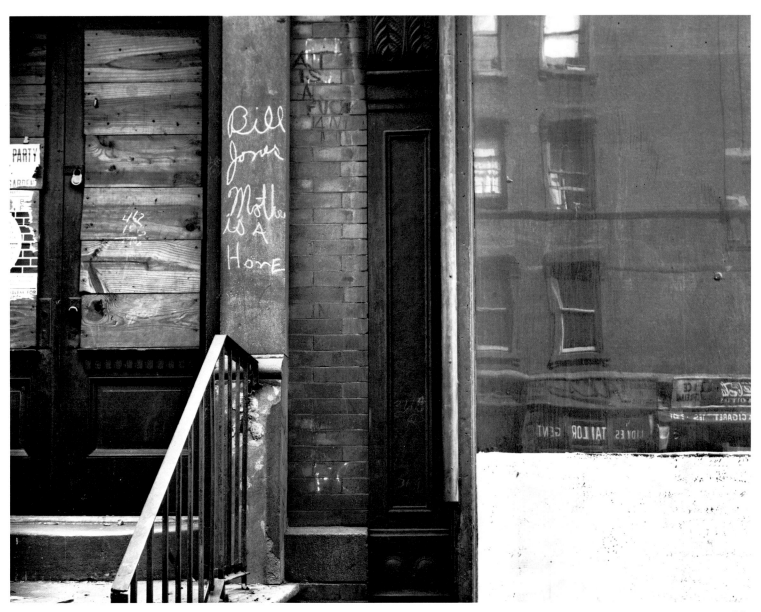

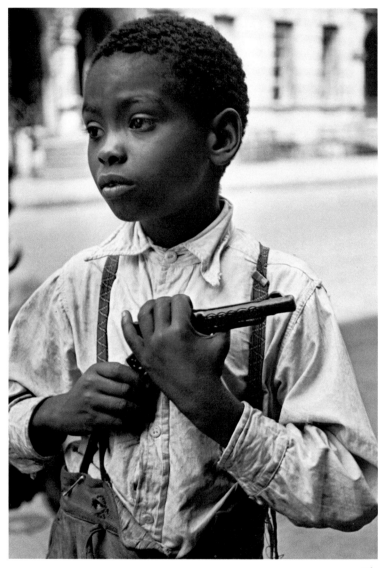

36

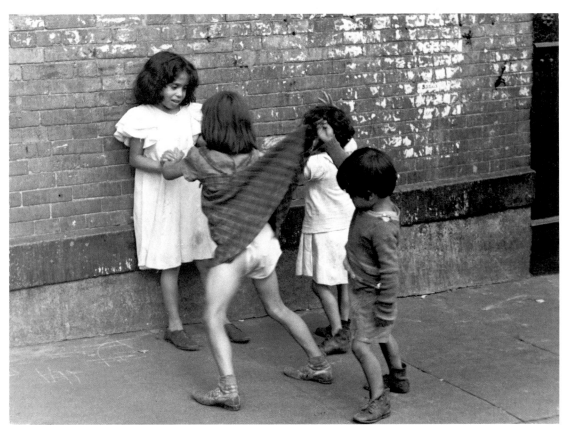

37

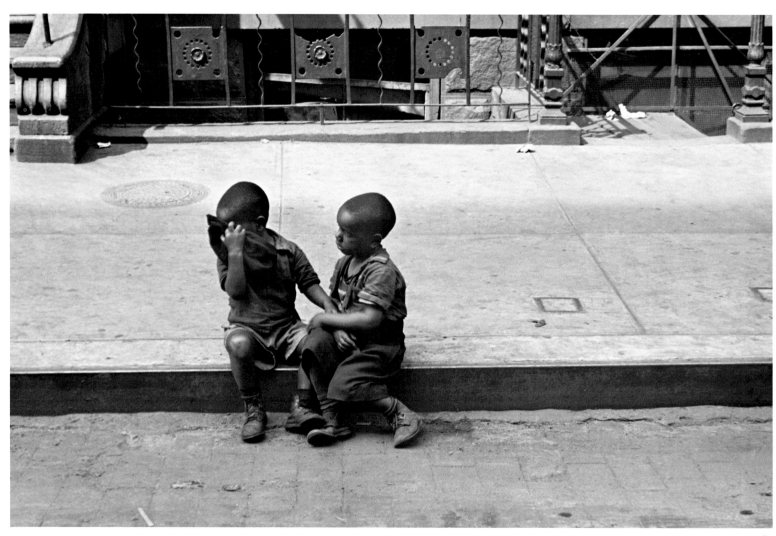

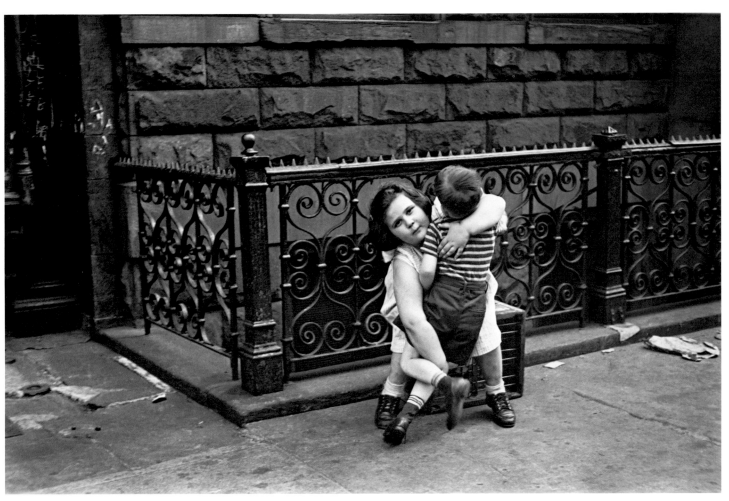

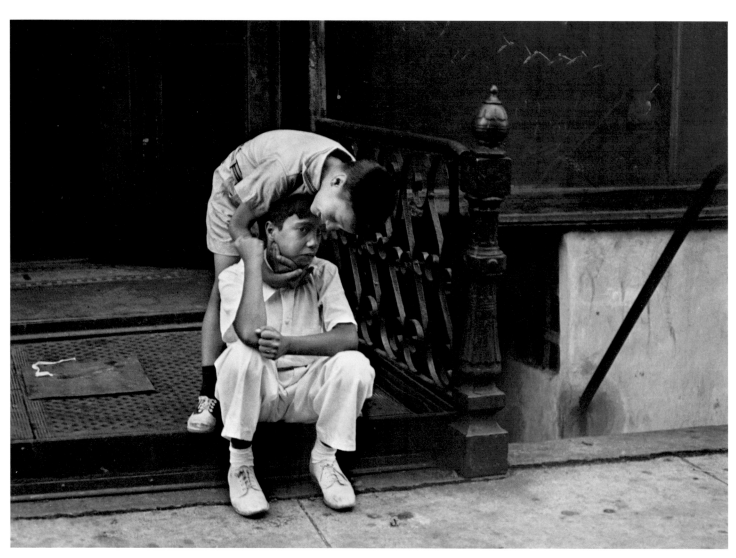

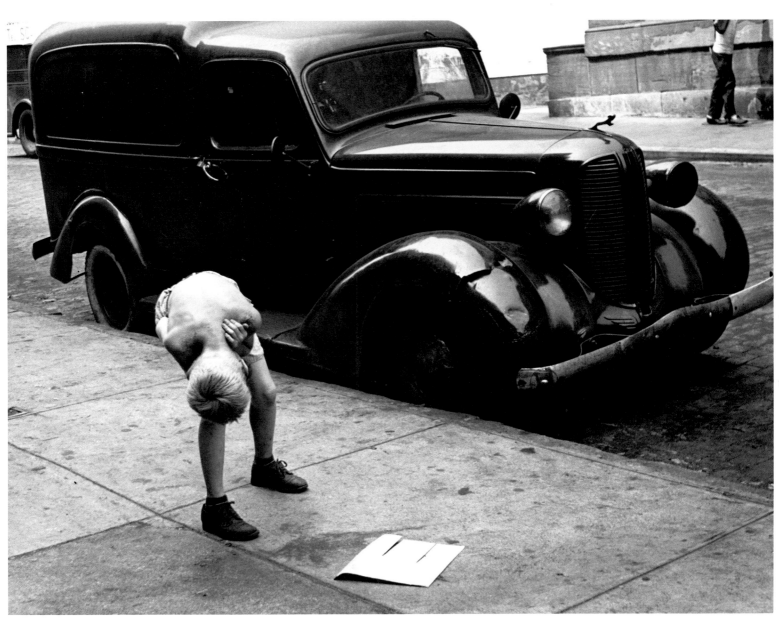

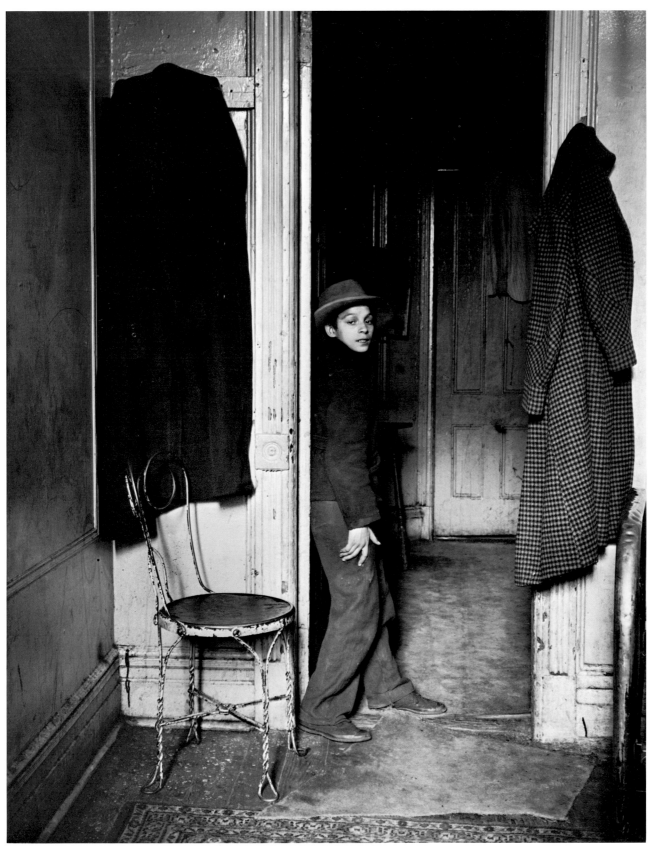

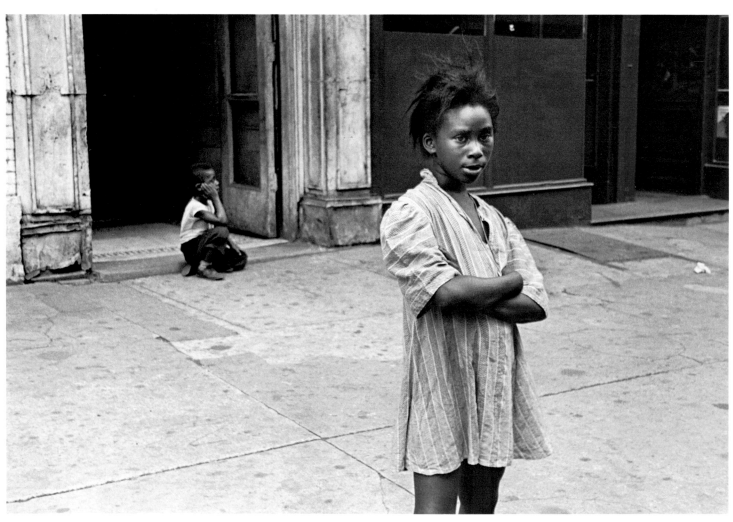

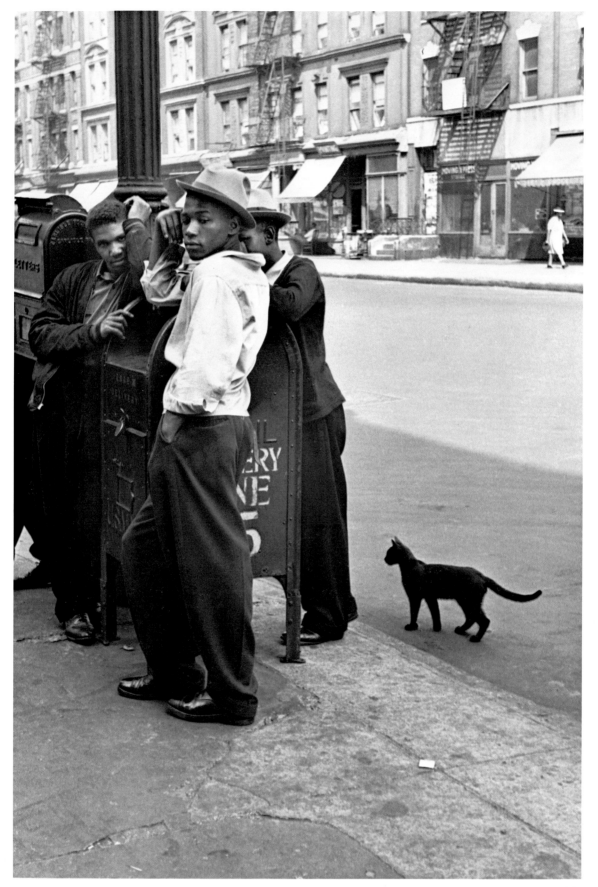

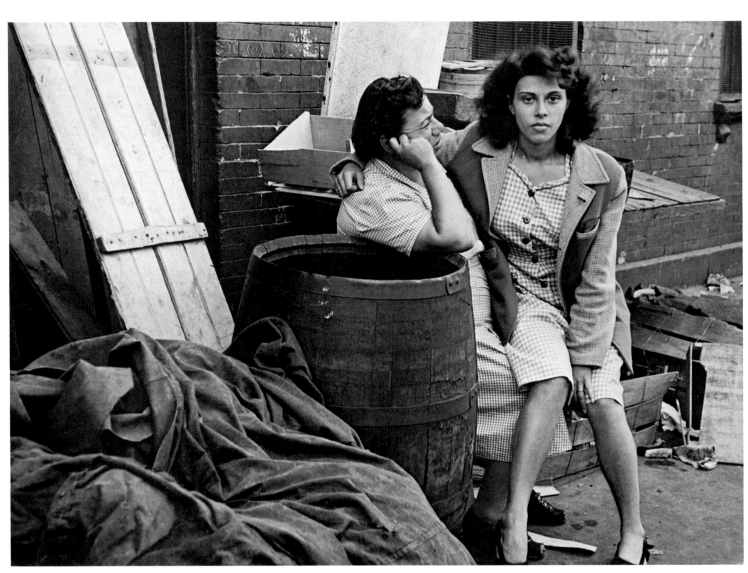

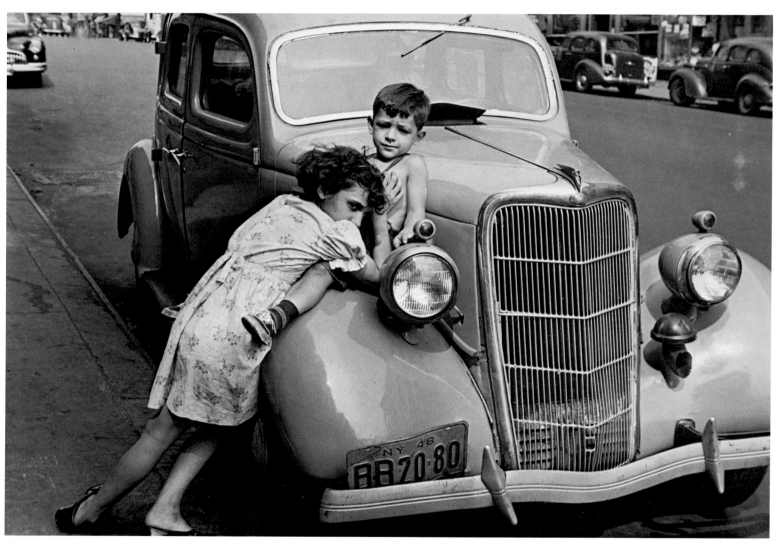

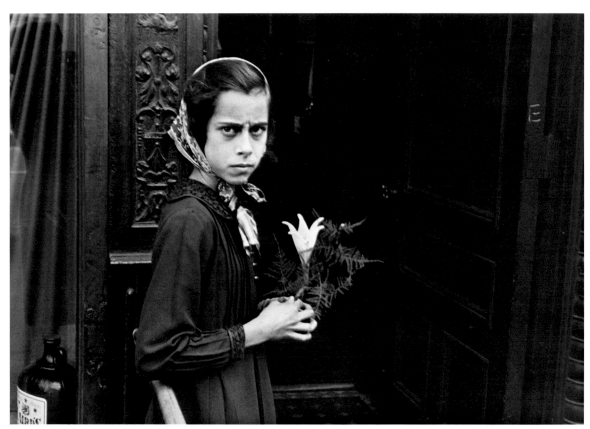

47

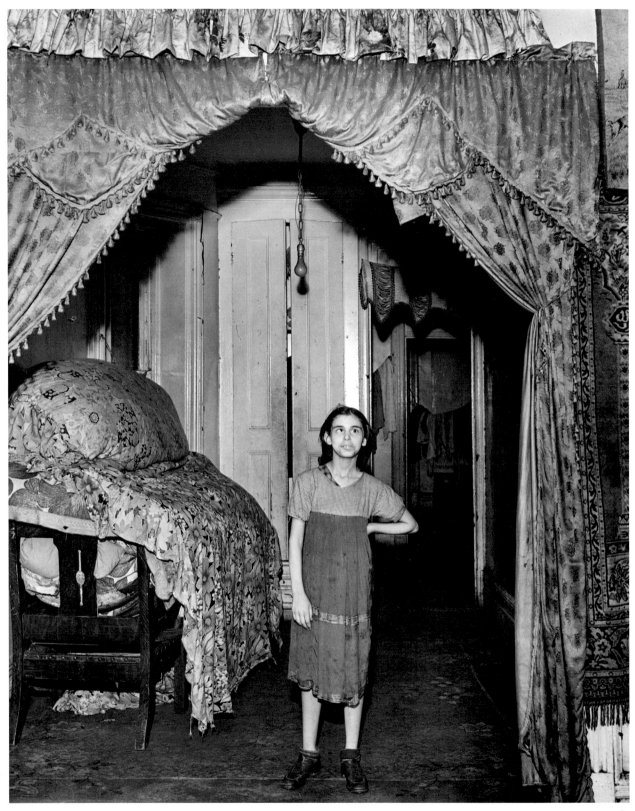

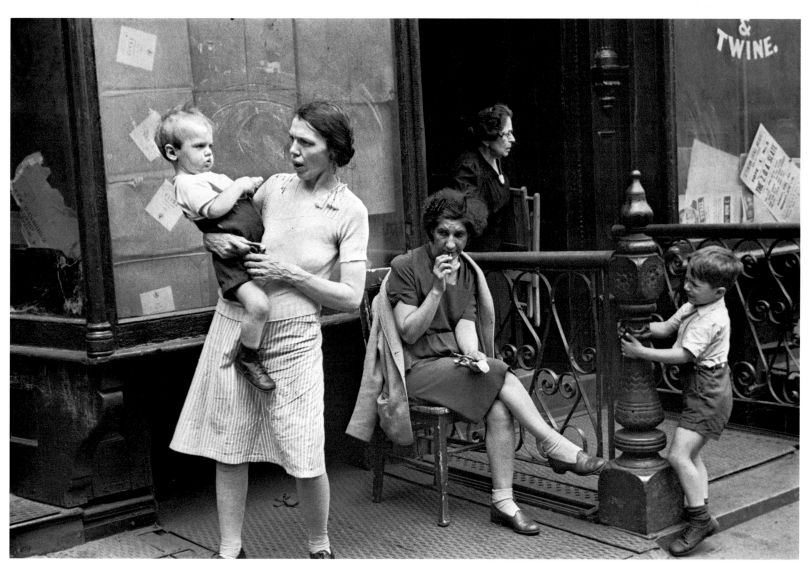

49

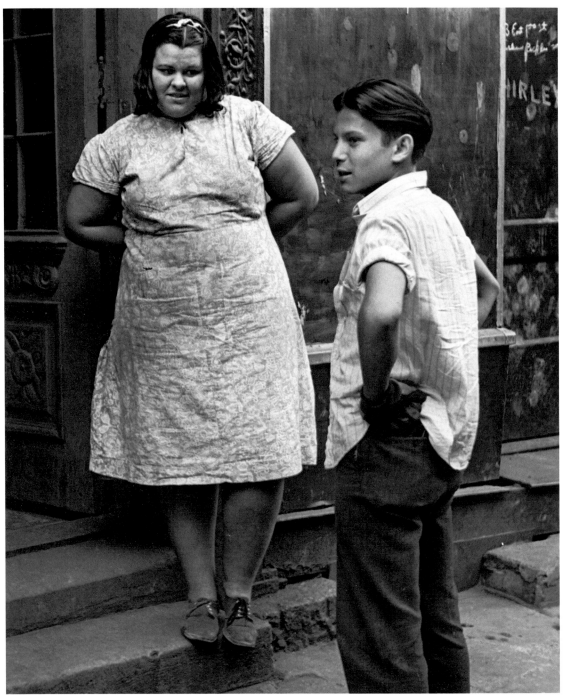

50

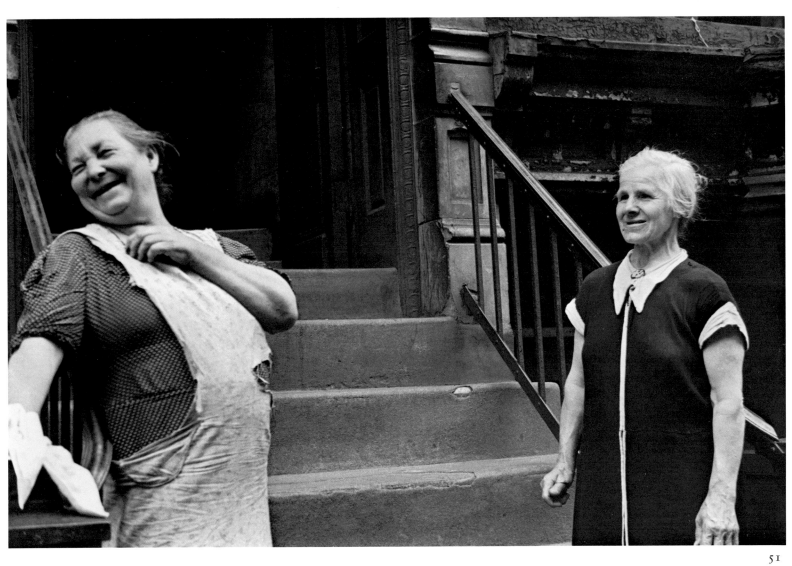

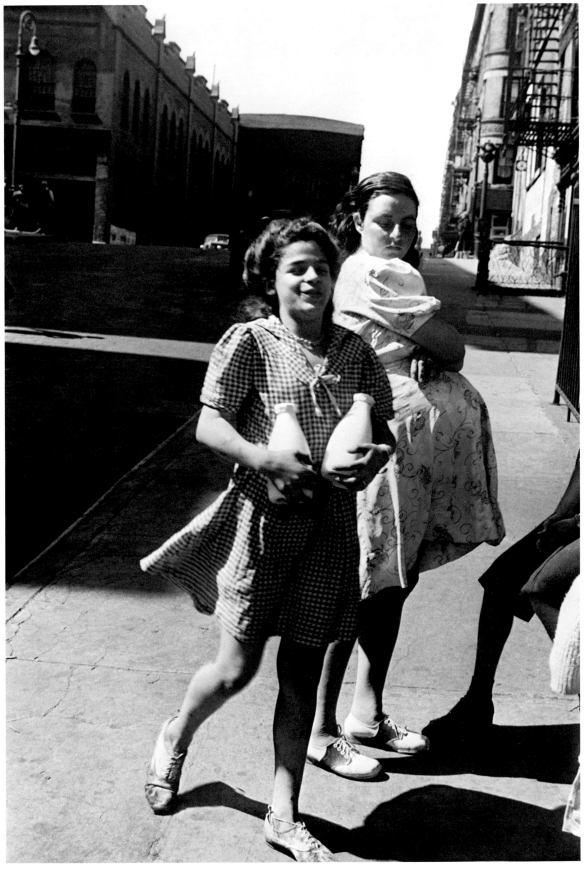

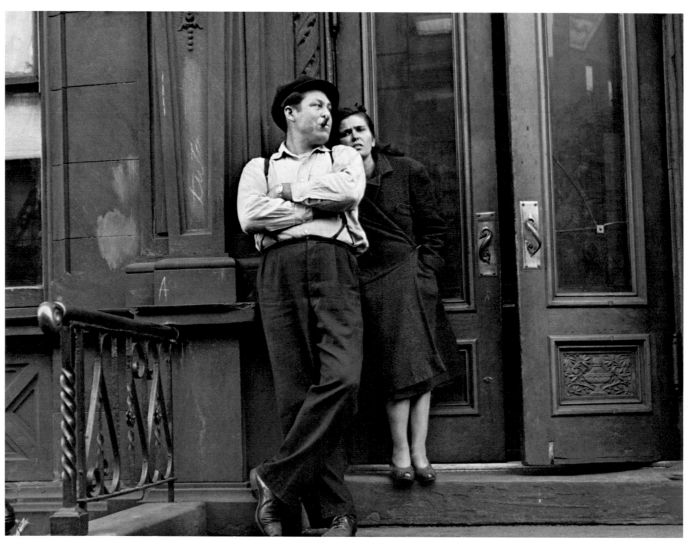

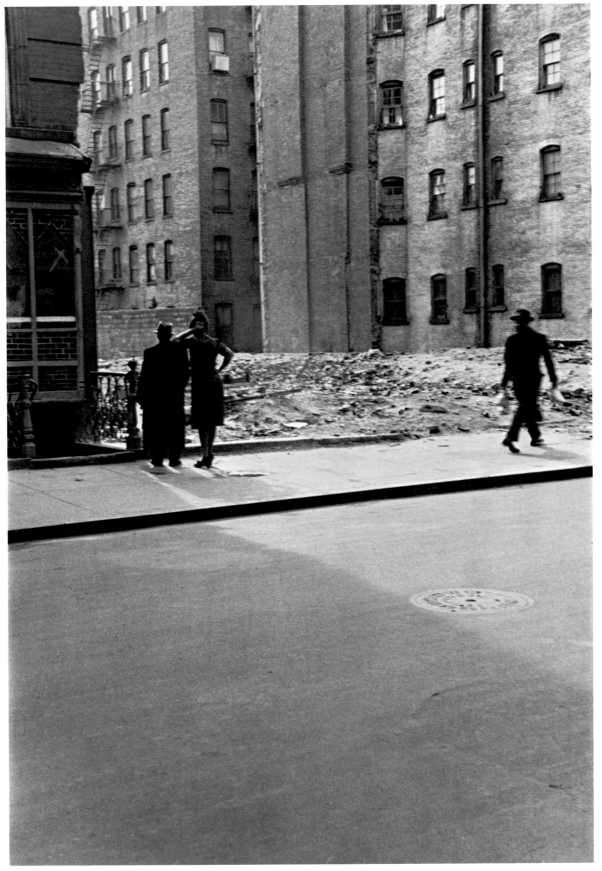

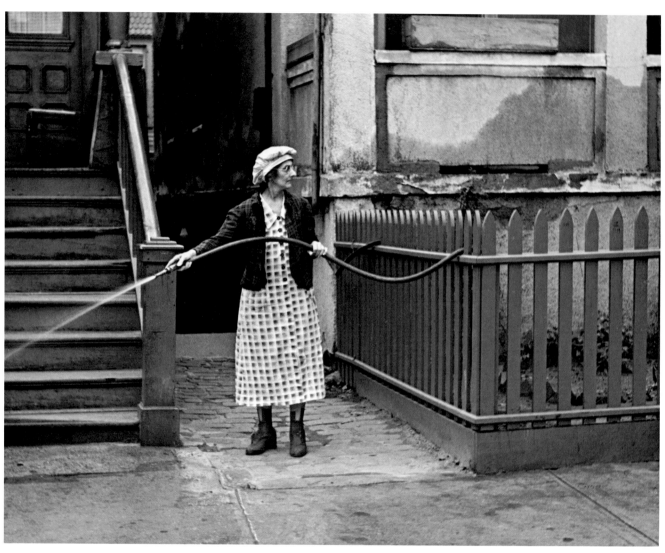

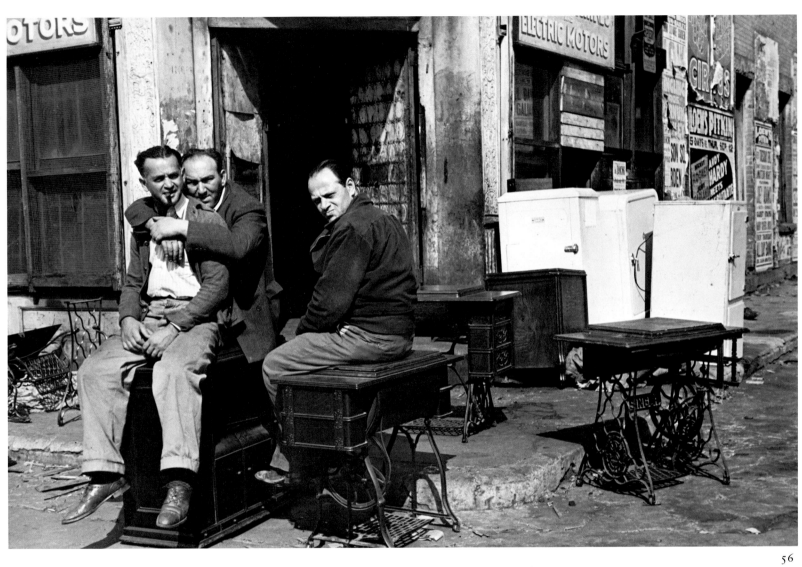

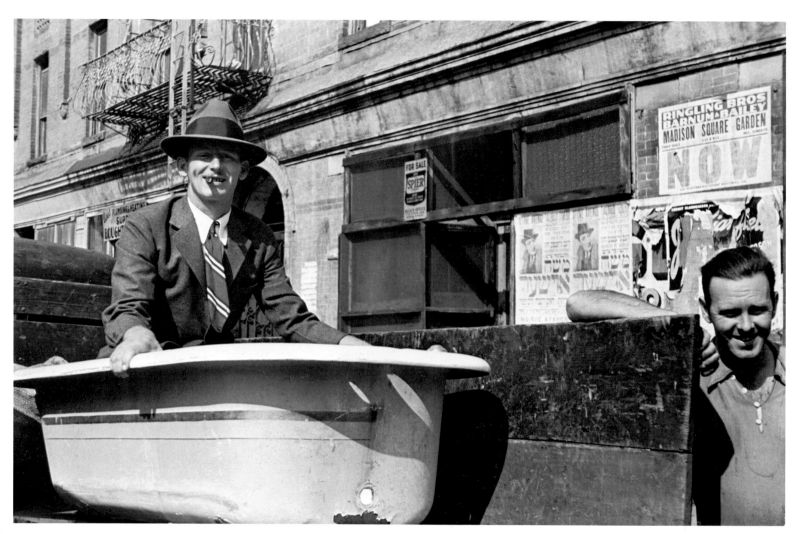

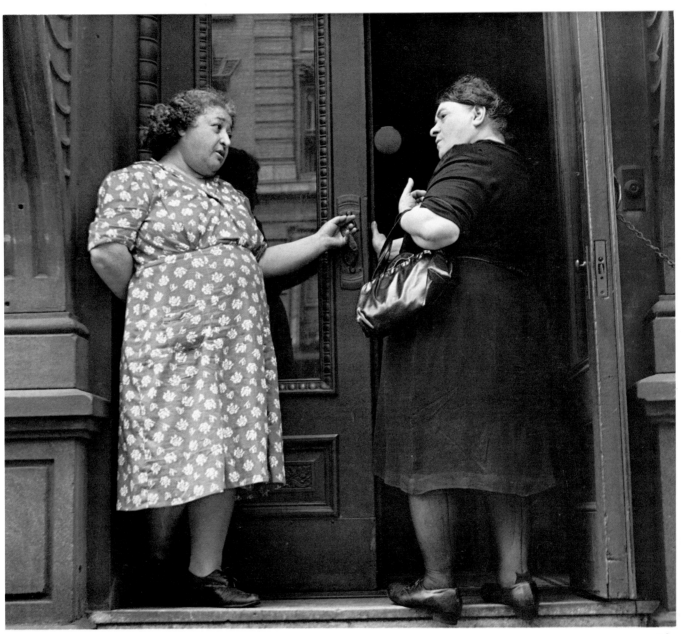

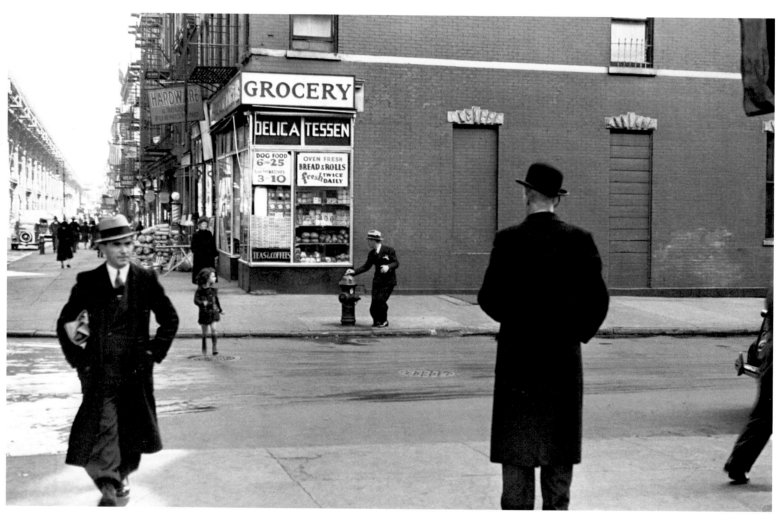

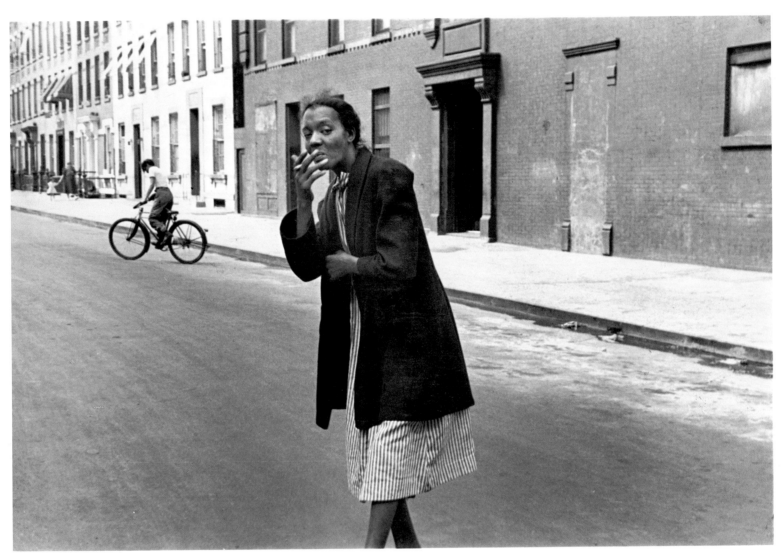

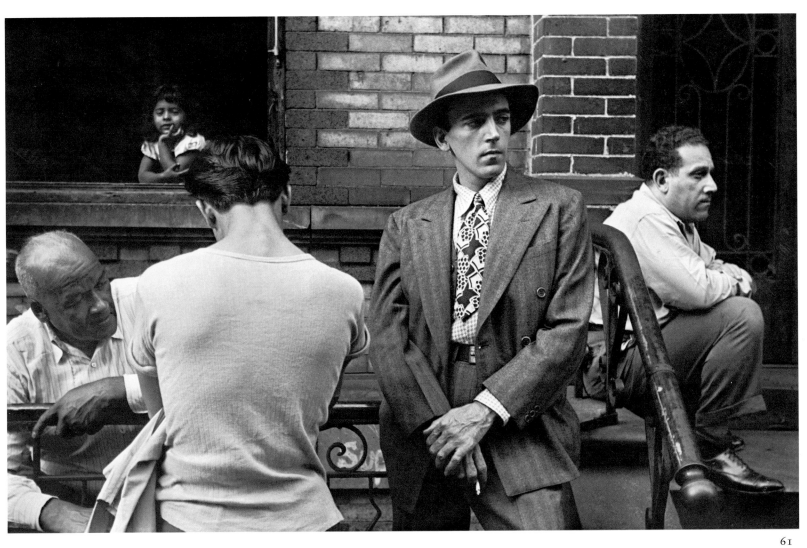

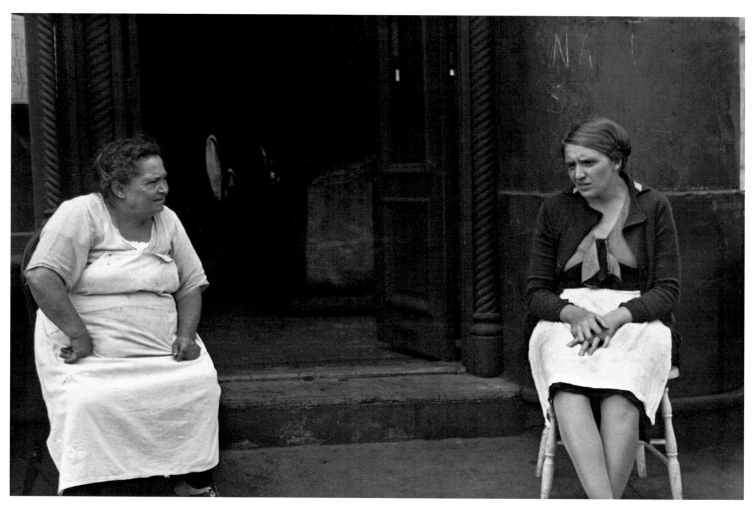

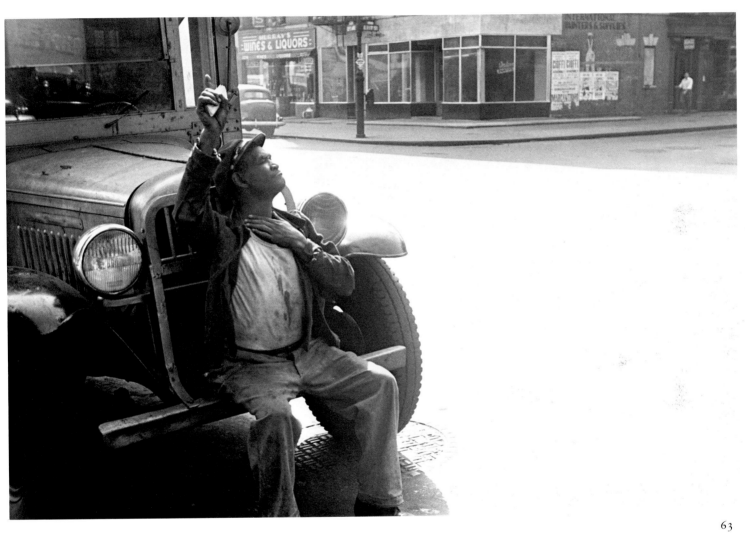

63

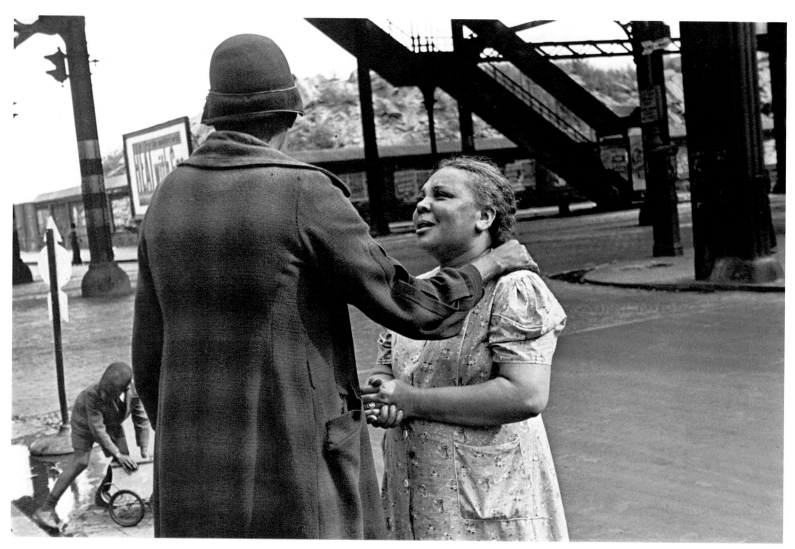

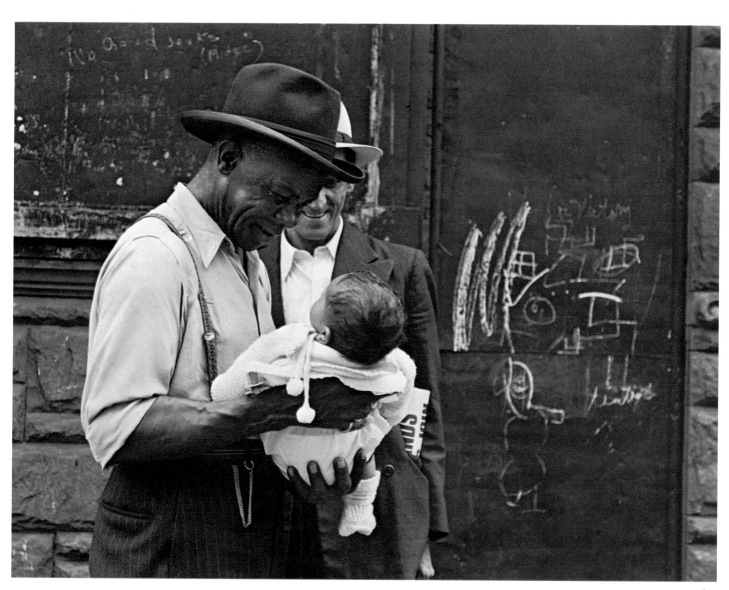

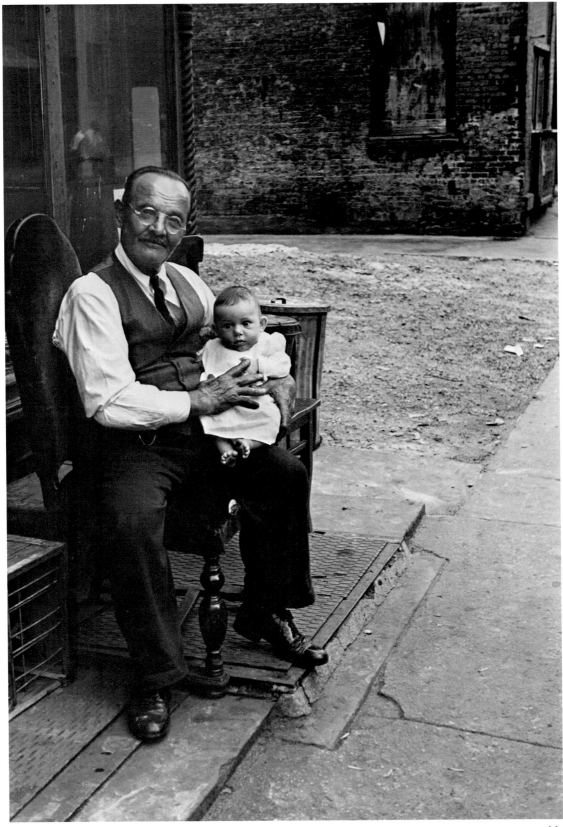

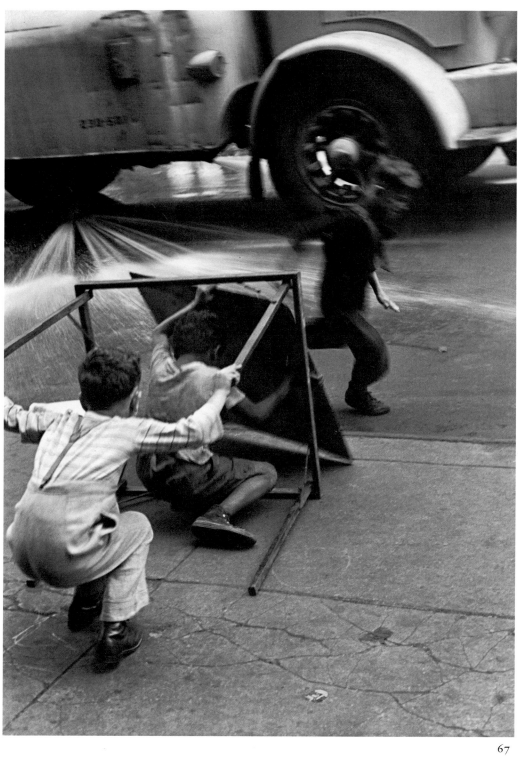

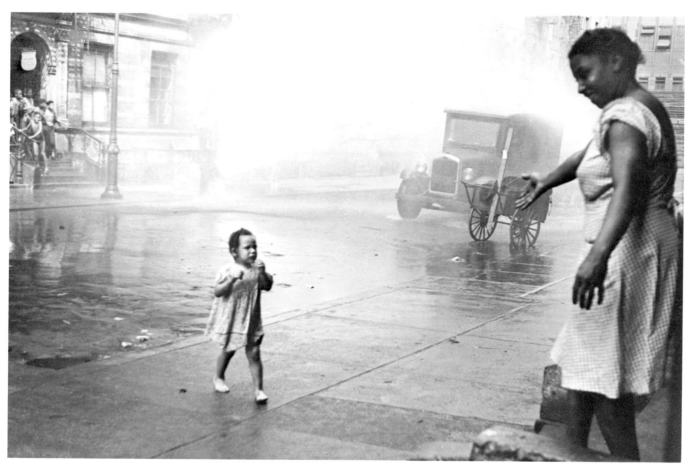